MW00844379

Magic Lantern Guides®

OLYMPUS®

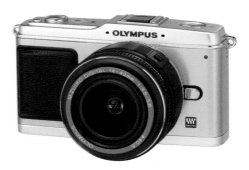

Frank Gallaugher

LARK
PHOTOGRAPHY
BOOKS

A Division of Sterling Publishing Co., Inc.
New York / London

Book Design and Layout: Michael Robertson
Cover Design: Thom Gaines

Library of Congress Cataloging-in-Publication Data

10 9 8 7 6 5 4 3 2 1

First Edition

Published by Lark Books, A Division of
Sterling Publishing Co., Inc.
387 Park Avenue South, New York, N.Y. 10016

Text © 2010, Frank Gallaugher
Photography © 2010, Frank Gallaugher unless otherwise specified

Distributed in Canada by Sterling Publishing,
c/o Canadian Manda Group, 165 Dufferin Street
Toronto, Ontario, Canada M6K 3H6

Distributed in the United Kingdom by GMC Distribution Services,
Castle Place, 166 High Street, Lewes, East Sussex, England BN7 1XU

Distributed in Australia by Capricorn Link (Australia) Pty Ltd.,
P.O. Box 704, Windsor, NSW 2756 Australia

This book is not sponsored by Olympus Corporation. The written instructions, photographs, designs, pat-
terns, and projects in this volume are intended for the personal use of the reader and may be reproduced
for that purpose only. Any other use, especially commercial use, is forbidden under law without written
permission of the publisher. The works represented are the original creations of the contributing artists.
All artists retain copyrights on their individual works, except as noted.

All product names or terminology are trademarks of Olympus Corporation. Other trademarks are rec-
ognized as belonging to their respective owners.

Every effort has been made to ensure that all the information in this book is accurate. However, due to
differing conditions, tools, and individual skills, the publisher cannot be responsible for any injuries,
losses, and other damages that may result from the use of the information in this book. Because specifi-
cations may be changed by manufacturers without notice, the contents of this book may not necessari-
ly agree with software and equipment changes made after publication.

If you have questions or comments about this book, please contact:
Lark Books
67 Broadway
Asheville, NC 28801
(828) 253-0467
www.larkbooks.com/digital

Manufactured in Canada

All rights reserved

ISBN 13: 978-1-60059-671-1

For information about custom editions, special sales, premium and corporate purchases, please con-
tact Sterling Special Sales Department at 800-805-5489 or specialsales@sterlingpub.com.

Contents

Introducing the Olympus E-P1

The Backstory

"OLYMPUS PEN Since 1959," inscribed on the cleft atop the E-P1, expresses a sentimentality quite absent from today's stoic and utilitarian digital cameras. The inscription refers to the successful PEN line of half-frame film cameras that made Olympus famous for packing impressive features and optics into a compact form factor—small enough to fit in a shoe, as the advertisements demonstrated. Olympus kept this small-but-capable reputation for camera design alive throughout the film age, represented best in their OM-series of SLRs and XA-series of compact rangefinders.

Note: The history of these cameras is an interesting read, and closely follows the life of a legendary camera designer named Yoshihisa Maitani. Check out www.olympus-global.com/en/corc/history/lecture for the full story.

The digital age has not been so fortunate in the area of compact design. Yes, there are more than enough compact digital cameras—these point-and-shoots take up the vast majority of the photographic market—but they suffer serious drawbacks as a result of their miniaturization: slow response times, limited manual controls, and (most of all) poor overall image quality as a direct result of their small sensors. At the other end of the spectrum are D-SLRs, which suffer none of these drawbacks but are seriously limited in how small they can be manufactured. As you can tell by the name, Digital-

◁ *Combining high-ISO capability with an image stabilization system, the E-P1 can capture low-light photos that are simply beyond the reach of small-sensor compacts. 1/8 second at f/4.5, ISO 800.*

SLR, the digital elements have largely been tacked onto existing SLR designs. As a result they are stuck with two extremely cumbersome components: an optical viewfinder and a mirrorbox. These extra components were necessary in film cameras, because there wasn't any way to focus, meter, or compose a scene through the film strip.

But a digital imaging sensor can do all this on its own. Contrast Detect Autofocus (CDAF) sensors can be installed directly onto the sensor, as can a complete metering system. And the sensor, by remaining active with the shutter open before the shot is taken, can provide a live preview of an image in real time, and relay that information to either an LCD screen or an electronic viewfinder (EVF). This preview system is called Live View, and is the digital alternative to an optical through-the-lens (TTL) viewfinder—even offering quite a few advantages over its film ancestor.

Olympus has carefully developed this Live View technology over the past several years, keeping it under the hood of its Four Thirds line of D-SLRs. It was only a matter of time before the technology bypassed the mirrorbox and viewfinder completely, to create a compact, Live View-only camera with an SLR-sized sensor. And sure enough, in 2009 Olympus introduced their first camera in the new Micro Four Thirds format: the E-P1.

Not a Point-and-Shoot
At any given megapixel (MP) rating, larger sensors mean larger individual pixels—there is simply more room for each one. So while a point-and-shoot with a small sensor may match the E-P1's 12MP resolution, the E-P1's larger pixels will always capture more light, output a stronger signal, and produce a cleaner, sharper image with better color accuracy. This is not to say there is no such thing as a decent point-and-shoot camera; there are many, and in ideal shooting situations there may be no visible difference in the final quality. The E-P1's edge comes into play the other 90% of the time, when the light is dim, the subjects are moving, and the world isn't a perfect studio shot.

Olympus is famous for the excellent color rendition of its image processors, and you'll find that the out-of-camera JPEGs are of such high quality that they rarely need post-processing. 1.3 seconds at f/8, ISO 200.

These are the most exciting times to take pictures, and when the E-P1 blasts most any point-and-shoot out of the water in terms of responsiveness, image quality, and feature count. In many regards it trumps even entry-level D-SLRs, with specs that line up favorably with advanced and semi-pro models (ISO up to 6400, 11 AF areas, Spot Metering, HD video capture, etc).

Additionally, the E-P1 supports interchangeable lenses—probably the most obvious factor distinguishing it from point-and-shoots. While there are plenty of decent multipurpose lenses, there's simply no such thing as a perfect lens for everything. So interchangeable lenses allow you to choose a specific lens for a particular purpose—wide-angle lenses for interiors and architecture, wide-aperture lenses for low light and portraits, telephoto for wildlife, and the list goes on and on.

Not an SLR

Here the difference is obvious: the E-P1 is considerably smaller and more portable than any D-SLR on the market. With the right lens, it can fit into a large pocket; and even when carried with its strap, it is noticeably lighter. This brings up a classic saying: the best camera is the one you have with you. D-SLRs may have larger grips, optical viewfinders, and lightning-fast autofocus systems, but their added weight often means they are left at home, where their photographic value is exactly zilch. The E-P1 begs to be taken everywhere, ensuring you're always ready to capture the shot when it reveals itself.

It's a PEN

Smaller camera bodies aren't just about convenience; they are specialized artistic tools, with advantages specifically relevant to the craft of photography. By virtue of their size, smaller cameras can infiltrate scenes and discretely capture subjects to reveal an undisturbed, earnest, and decisive moment in a way larger, distracting cameras simply cannot. Combining that discretion with a high-quality imaging system results in a powerful photographic instrument, so it's no wonder that the E-P1 is a breath of fresh air for photographers everywhere.

The Purpose of this Guide

Rhetoric aside, the important thing is that you learn the ins and outs of your new E-P1. The camera is extremely complex, and many features and functions can be confusing or counterintuitive. The following pages will clear up that confusion, using simple language to explain the details of every feature and function, with tips and shortcuts to maximize the camera's performance and capabilities. Whether you're a beginner who will benefit from overviews of the basics, or an experienced photographer who can't make heads or tails of the labyrinthine menu system, this guide will get the camera out of the way, allowing you to express your own personal style and flex your own creative muscle.

1/10 second at f/3.5, ISO 800.

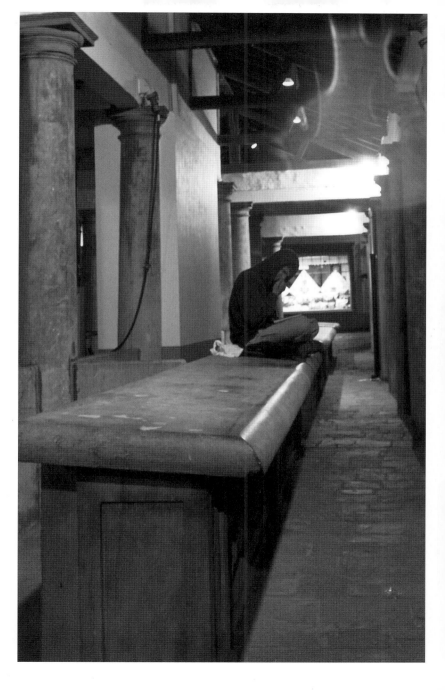

Getting Started

Prepping the Camera

Attaching the Neck Strap

At either end of the supplied neck strap are two pieces of plastic: a buckle with the loose strap end passed through it, and a clamp that slides freely along the folded strap. Undo the ends of the strap from both of these plastic parts, taking care not to let the clamps slide off the ends. Lay the strap out to the right of the camera so that the Olympus logos are face down. Next, pass about six inches (15.4 cm) of the loose end of the strap up through the lug on the right side of the camera, fold it back over itself and through the clamp, and slide the clamp down toward the camera so that a loop is formed. Then push the remaining length of the strap down through the slot of the buckle that is closest to the camera, and pull it up through the other slot. When you pull the full strap tight, there shouldn't be any slipping or loosening. Fold the long end of the strap over to the other side of the camera, and repeat these steps for the left lug. If the strap is tight, supports the weight of the camera, and has its Olympus logos facing outward without any twists, then it's successfully attached. Luckily, you only have to do this once!

Attaching and Removing a Lens

With the camera front facing you, rotate the body cap counterclockwise until it comes loose from the body. Do the same for the rear lens cap. Then line up the red dot on the lens with the red dot on the left side of the camera's lens

While it can fit into large pockets or small bags, I recommend keeping the E-P1 around your shoulder for general shooting. Its weight is negligible, and you'll be more inclined to grab good photos when they present themselves. 0.6 seconds at f/4, ISO 400.

mount, push the lens in slightly, and rotate the lens clockwise until you hear it click into place. To remove the lens, press the Lens Release button on the right of the camera front, and rotate the lens counterclockwise until it releases from the body.

Charging and Inserting the Battery

Unwind the power cord that is supplied with the BCS-1 battery charger; plug the female end into the charger, and the male end into a power outlet. Then drop the BLS-1 battery into the charger, face down with the arrow facing the cord. A red LED will alight to indicate the battery is charging. When the LED turns blue, charging is complete.

Next, turn the camera upside down and open the battery compartment cover by sliding the black latch toward the camera back in the direction indicated by the arrow over the word **OPEN**, pulling the compartment cover up so it rests in an open position. Slide the battery into the compartment with the bottom of the battery (the side with the sticker and description on it) facing the front of the camera. Push it all the way down until the small grey release lever snaps over it—don't force it! If the grey release level does not snap in place, then the battery is inserted backward.

Inserting and Formatting the Memory Card

With the battery compartment cover still open from the previous step, take an SD or SDHC card (not supplied with the camera) and slide it into the small slot just above the battery with the card's contacts facing the camera back and the diagonal edge lining up as indicated by the diagram next to **PUSH TO EJECT**. Close the compartment cover by pressing it against the bottom of the camera until the black latch snaps into place.

Press the **ON/OFF** button atop the camera; a green circular light should glow around the button to indicate it is powered on. Press the **MENU** button, then press the right-arrow button twice so that the **CARD SETUP** menu appears. Press the down-arrow button and then the ⊛ button so that the **FORMAT**

submenu appears. Press the up-arrow button so that **CAUTION ERASING ALL** appears, and then press the ⓞⓚ button again. A progress bar will appear briefly, and when the LCD goes blank, the card is successfully formatted.

Hint: Though the E-P1 will be able to record on any SD or SDHC card, Olympus recommends a class 6 SDHC card to support the faster write times demanded by recording HD video.

Setting the Time and Date

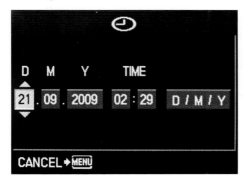

Recording an accurate time and date with each image file is a big help when organizing photos later on a computer.

With the camera still powered on, press the **MENU** button again, press the up-arrow button once, and then the right-arrow button twice. The 🕐 menu shown here will be displayed on the LCD screen. D is the day, M is the month, and Y is the year. Adjust each value with the up-down arrows keys, and advance to the next value using the left-right arrow keys. The value on the far right determines the order in which the day, month, and year appear on the LCD screen during playback. When the date is set correctly set, half-press the shutter-release button atop the camera.

Experiment with the camera's features until you find a comfortable balance between its automation and your personal creative style. You don't have to calculate each and every exposure in your head, but you should take a moment to decide what is important to the shot. 1/200 second at f/3.5, ISO 500.

Quick Shooting Guide

Since I doubt anyone has the patience to read this entire guide from cover to cover before ever taking a shot with their new camera, what follows below is a crash course in automated shooting, to get you started. Detailed explanations of several features follow in subsequent chapters.

Note: Before shooting with the M. Zuiko Digital ED 14-42mm f/3.5-5.6 kit lens, you must first rotate the zoom ring counterclockwise until it snaps in place at the 14mm mark. Otherwise, the LCD will tell you, rather cryptically, to "Please check the status of a lens." And obviously, be sure to remove the lens cap before attempting to shoot.

Shooting in **iAUTO** Mode

Locate the Shooting Mode Dial at the top left of the camera, and rotate its protruding wheel until **iAUTO** lines up with the indented marker to the left. The **iAUTO** icon will appear at the upper left of the LCD screen, along with a series of other icons indicating various settings and functions. In this fully automated shooting mode, the camera sets the shutter speed, aperture, and white balance, using the 🔲 metering mode. You have full control over the drive mode (page 51), IS mode (page 57), aspect ratio (page 59), and resolution (page 60). You can also set the autofocus (AF) mode (page 52), but the camera will always use all eleven [∷∷] AF areas and ☻ Face Detection is always enabled. And finally, the flash mode (page 101) is limited to either AUTO or ④ OFF.

Camera-Holding and Shooting Techniques: Though the E-P1 is equipped with a capable Image Stabilization (IS) system, you should nevertheless always hold the camera as steadily as possible to ensure optimal image quality. The most reliable way to hold the camera is with two hands: the left hand should grasp the lens in between the thumb and forefingers, providing easy access to the zoom (if applicable) and focus ring while also using the palm to support the camera from below; the right hand should have the index finger on the shutter-release button and the remaining fingers covering the raised, black grip on the camera front. This leaves the right thumb free to make all the essential adjustments using the controls on the camera back.

Stand with your feet slightly apart, lining up with your shoulders, and brace your elbows against your torso. When you've composed an image on the LCD, half-press the shutter-release button to activate the autofocus and autoexposure systems. If you hear a chirp, that's the autofocus confirmation alert—also indicated by a green dot that appears at the upper-right of the LCD—meaning the camera is ready. Take a breath, and then fully press the shutter-release button to capture the image.

Hint: Resist the urge to hold the camera out at arm's length; this sloppy point-and-shoot stance is attention-gathering, imprecise, and shaky. Hold the camera as close to your body as your eyesight will allow. Also resist the urge to jerk the camera as you fully press the shutter-release button; it only takes a delicate touch.

Autofocus Lock: If the AF confirmation chirp doesn't sound and instead the green dot flashes in the upper-right of the LCD, that means the autofocus has failed, and the shutter will refuse to fire. This happens when there is insufficient light, or when the scene is too low-contrast. As its name states, the Contrast Detect AF system is entirely dependent on there being some degree of contrast in a scene. Contrast is the difference between light and dark areas, so a blank white wall—where there are only light values—is just as impossible to focus on as a pitch-black room.

If the AF is struggling, aim the camera at another, better-lit or higher-contrast subject (look for light sources or shadows) that is roughly the same distance from the camera as your intended subject. Half-press the shutter release, and (with luck) the camera will chirp to indicate successful autofocus. Now, keeping the shutter release half-pressed, recompose the shot around your intended subject, and fully press the shutter-release button. The shutter will immediately fire, because it has kept the focus position from the earlier subject.

This technique, called autofocus (AF) lock, is also applicable to action shots, which may otherwise be missed due to the time it takes to achieve autofocus. By pre-focusing on the spot that you predict action to occur, you can eliminate any shutter lag and capture the shot the instant the shutter release is fully pressed.

Note: See pages 52-55 for more information on the autofocus system, including manual focus.

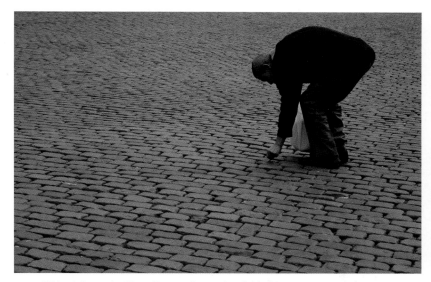

AF lock is easier than it sounds, and quickly becomes second nature. This shot was first focused with the crouching figure in the center, using the center AF area; then, with the shutter-release kept at its half-pressed position, it was re-framed for a more interesting composition. 1/1000 second at f/5.6, ISO 200. © Sven Thierie

Check the Shot

The ability to evaluate a shot immediately after it is captured and recorded is a hallmark of digital photography. By default, a captured image will be displayed on the LCD for five seconds (adjustable via the **REC VIEW** menu item—see page 113). To evaluate it for longer, press the ▶ button. Check that the composition was satisfactory, and inspect the colors for accuracy. If it all looks good, congrats! Press the ▶ or shutter-release button again to return to shooting mode.

Note: See pages 73-87 for much more information on image playback.

Basic Features and Operation

Camera Controls

The E-P1 sports an impressive array of dedicated manual controls, in the forms of buttons and dials, that allow immediate access to all the most-frequently used settings and functions, and save you from wasting time digging through the menu system.

Command Dials
The circular main command dial surrounds the Ⓢ button on the camera back, and can be rotated clockwise or counterclockwise. The vertical subcommand dial, at the top right of the camera back, can be rotated left or right. These are the primary means of adjusting settings during shooting, and their respective functions depend on the current shooting mode.

Note: The function of each command dial is customized in the **DIAL FUNCTION** submenu of the 🔲 **BUTTON/DIAL** menu item—see page 117.

Arrow Keys: In addition to being rotated clockwise or counterclockwise, the circular main command dial can also be pressed up, down, left, or right. In any of the shooting info screens (page 41), these are referred to as 📷, 📷, 📷, and 📷 buttons, as they access menus in which their various dedicated functions can be adjusted. However, as soon as any menu is displayed, these buttons lose their dedicated function status and become simple directional arrow keys used to navigate through the various options displayed on the screen.

🔾 *Direct access to critical functions via dedicated controls and buttons distinguish the E-P1 from typical compact cameras. The goal is to learn them so well that you can make on-the-fly adjustments without any delay, letting you concentrate on what's important: getting the shot. 1/640 second at f/6.3, ISO 200.*

Front View

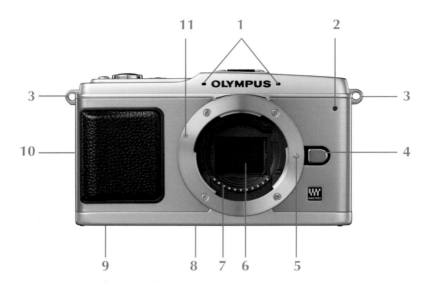

1. Microphones
2. Self-timer lamp
3. Camera strap eyelets
4. Lens release button
5. Lens lock pin
6. Imaging sensor

7. Electronic lens contacts
8. Tripod mount
9. Battery/SD card cover
10. Connector cover
11. Lens attachment mark

Rear View

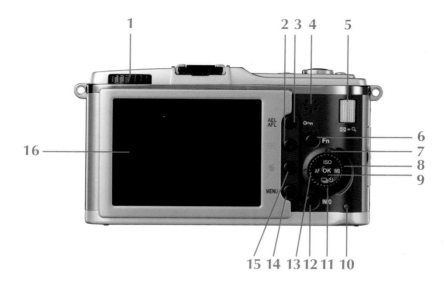

1. Shooting mode dial
2. Playback ▶ button
3. AEL/AFL button
 Protect ⌒ button
4. Speaker
5. Subcommand dial
6. Fn button
7. ISO 🔘 button
8. White balance 🔘 button
9. ⊛ button
10. Card access indicator
11. Drive mode 🔘 button
12. INFO button
13. Autofocus (AF) mode 🔘 button
14. MENU button
15. Delete 🗑 button
16. LCD screen

Top View

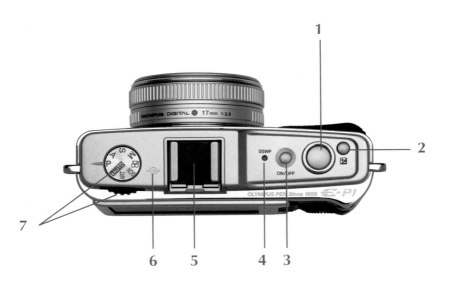

1. Shutter-release button
2. Exposure compensation
 ⚡ button
3. Power button
4. Super Sonic Wave Filter
 (SSWF) indicator
5. Hot shoe
6. Focal plane mark
7. Shooting mode dial

Being able to immediately see its effects in Live View makes exposure compensation much easier to use. 1/160 second at f/10, ISO 200.

The arrow keys and the control dials serve the same function while in a menu: the up-down arrow keys and the main control dial both scroll vertically, and the left-right arrow keys and the subcommand dial both scroll horizontally.

⊞ Exposure Compensation

While the E-P1's metering system is remarkably accurate, it can sometimes render an image darker or brighter than you like. Exposure compensation allows you to override the metered exposure by +/-3EV. To set an exposure compensation, hold down the small ⊞ button atop the camera while rotating the subcommand dial left for negative compensation (a darker exposure) or right for positive compensation (a brighter exposure). While you are adjusting the exposure compensation, a new yellow numeral will appear to the right of the aperture value at the bottom of the LCD screen. Releasing the ⊞ button will revert back to normal shooting mode. Exposure compensation is available in all shooting modes except **SCN**, **iAUTO**, and **M** modes.

The LCD Screen

Eschewing a built-in optical or electronic viewfinder, the EP-1 relies on its 100%-coverage, 3-inch (7.6 cm), 230,000-pixel LCD screen for image composition. It can be viewed from up to a 176-degree angle and is remarkably clear and visible even in bright sunlight (though in direct sunlight, it is sometimes necessarily to cup one hand around the top of the LCD to cast a little shade). Because the image presented on the LCD is a direct feed from the sensor itself (well, ignoring any applied distortion correction—see page 90), you can immediately see the exposure and effects of white balance, picture tones, and art filters.

The Live Control Menu

1. *White Balance (WB)*
2. *Drive Mode*
3. *Image Stablization (IS) Mode*
4. *Aspect Ratio*
5. *Resolution*
6. *Flash Mode*
7. *ISO*
8. *Metering Mode*
9. *Focus Mode*
10. *Face Detection*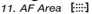
11. *AF Area* [::::]

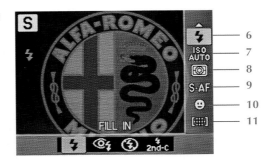

*If you find the LCD screen difficult to view in harsh lighting condi-
tions, you can adjust its brightness in the* ⚐ 🖳 *submenu
(page 113).*

Pressing the ⑳ button while shooting in Live View calls
up the Live Control Menu. This menu operates on two axes.
The vertical axis along the right of the LCD displays icons for
eleven functions that can be cycled through using either the
main command dial or the up-down arrow keys. As each
function icon is highlighted, its relevant settings appear along
the horizontal axis at the bottom of the LCD, which can be
cycled through using either the sub command dial or the left-
right arrow buttons. By highlighting a different settings icon
on the horizontal access, you've adjusted that setting for its
relevant function—there's no need to confirm each selection.

As it operates in two dimensions, the Live Control Menu
definitely takes some getting used to; but it quickly becomes
second nature and that's exactly the point. It offers dozens of
adjustments without ever obscuring the image displayed in
Live View, all with just one pair of controls. I recommend
combining the vertical control of the main control dial with
the horizontal control of the left-right arrow buttons; that
way your thumb never even leaves that one dial.

The Super Control Panel

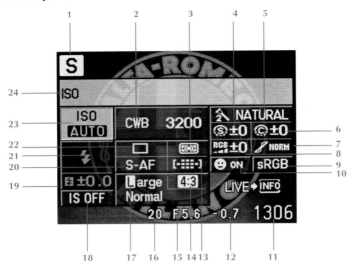

1. *Current Shooting Mode*
2. *White Balance (WB)*
3. *Metering Mode*
4. *Sharpness* ⓢ
5. *Picture Mode*
6. *Contrast* ⓒ
7. *Gradation* 𝄃
8. *Saturation* ᴿᴳᴮ
9. *Color Space*
10. *Face Detection* ☻
11. *Shots Remaining*
12. *Exposure Compensation* ☒

13. *AF Area* [⋮]
14. *Aspect Ratio*
15. *Aperture Value*
16. *Shutter Speed*
17. *Resolution*
18. *Image Stabilization (IS) Mode*
19. *Flash Exposure Compensation* ☒
20. *Focus Mode*
21. *Flash Mode*
22. *Drive Mode*
23. *ISO*
24. *Currently Selected Function*

As if the dedicated controls and Live Control Menu didn't offer sufficient ease of operation, pressing the **INFO** button again while in Live Control Menu will switch to the Super Control Panel. This is another shortcut designed to spare you from repeatedly descending into the menu system, adding nine new functions to the eleven in the Live Control Menu. The tradeoff is that this menu screen obscures the Live View image, overlaying the entire center of the frame with its barely translucent screen.

Shooting Modes

On the top left of the camera, you'll find the Shooting Mode Dial, showing eight different modes on the top of the dial, which can be rotated using the notched thumb wheel that extends out the back. The currently selected mode is the one at the 9-o'clock position, lining up with the small indentation on the left. As described in the last chapter, iAUTO is the most basic and fully automatic shooting mode, and is useful for casual snapshots; but to flex your creative muscle, you'll really want to start playing around with the other shooting modes.

Programmed Autoexposure (P)

This shooting mode is one step up from **iAUTO**, in that the camera automatically sets what it determines to be the correct shutter speed and aperture for a perfect exposure, and displays those values as white numerals at the bottom of the LCD—and that's all it does. You have complete control over all the other settings: ISO, AF mode, WB, exposure compensation, etc. Additionally, you can change the combination of shutter speed and aperture values by rotating either of the command dials—a process called Program Shift. The brightness of the exposure will stay constant, because the aperture and shutter speed values shift inversely relative to each other—which is to say, rotating a command dial to the right will both increase the shutter speed and decrease the aperture value, and rotating to the left decreases shutter speed while increasing the aperture. To brighten or darken the exposure, you must use ☒ exposure compensation. When a subject is too bright or too dark for any combination of shutter speed and aperture, those two numerals will blink. In this case, it's up to you to increase or decrease the ISO (page 47), or use an external flash (page 97).

Aperture-Priority (A)

This shooting mode gives you control over the aperture, displayed in yellow at the bottom of the screen. You set the aperture, and it will stay at that value no matter what; the camera set a corresponding shutter speed in order to achieve an accurate exposure. Like in P mode, the shutter speed will shift inversely relative to your selected aperture, so the overall exposure remains constant. To increase or decrease the brightness of the scene, you have to use ⊞ exposure compensation. All other features (ISO, white balance, etc) remain available for you to adjust.

Depth of Field: There's another important aspect of aperture beyond just the level of brightness in the exposure. Wide apertures (low f/stops) limit the area in focus to a selective area in front of and behind the subject. Narrow apertures (high f/stops) maximize what is in focus, so that everything from a nearby flower to a distant mountain range appears sharp. This range of what appears sharp and in focus is called the depth of field, and is a major part of the creative control photographers have in their images.

Shutter-Priority (S)

Shutter-Priority mode is the exact opposite of Aperture-Priority: you select the shutter speed, which appears as a yellow numeral at the bottom of the LCD, and the camera sets a corresponding aperture. Again, all other functions and settings remain available. Unlike aperture, however, available shutter speeds depend on the camera. In S mode, the possible shutter speeds range from 60 seconds to 1/4000 second.

Whereas Aperture-Priority is all about depth of field and subject isolation, Shutter-Priority is all about action and motion. High shutter speeds can freeze a split second of action—like a basketball player making a slam dunk in mid-air—and low shutter speeds, by blurring a subject, communicate a sense of movement. Low shutter speeds benefit from the EP-1's image stabilization system (see page 57), but that only operates at shutter speeds of 2 seconds

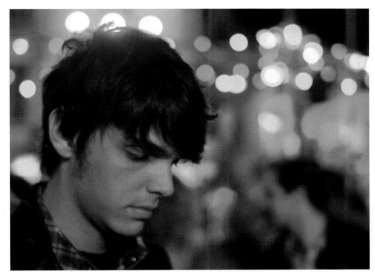

Here you can see the dramatic effects of shallow depth of field. The main subject pops out of the scene, while the smoothly blurred background gives a festive ambience to the shot. 1/125 second at f/1.4, ISO 1600.

or faster. For lower shutter speeds (in very low light, or when using a very narrow aperture) best results are achieved using a tripod.

Manual Exposure

This shooting mode gives you simultaneous control of both shutter speed and aperture, and the camera's autoexposure system only acts as a light meter to aid in achieving exposure. By default, the main control dial controls shutter speed and the subcommand dial controls the aperture; both of these values appear in yellow at the bottom of the LCD. Note that exposure compensation doesn't exist in this mode, and in its place the camera gives an exposure deviation readout in white numerals at the bottom right of the LCD. Positive EV deviation means the camera thinks your current settings will result in an overexposure, and that you should

increase shutter speed or decrease the aperture to compensate. Negative EV deviation means just the reverse. When the EV deviation is 0.0, the camera deems the exposure to be perfect.

Additionally, Bulb shooting is available in **M** mode by decreasing the shutter speed past 60 seconds until **BULB** appears in yellow at the bottom of the LCD. In this mode, the shutter will remain open as long as the shutter-release button is held down. The time available for Bulb shooting is set in the 🔲 **BULB TIMER** submenu (page 133). And whether or not focusing remains possible during bulb shooting is determined in the 🔲 **BULB FOCUSING** submenu (page 116).

Movie Mode 🎥

The ability to record hi-definition video is one of the headlining features of the EP-1. At its highest resolution, the camera records at 720p in 16:9 aspect ratio. This means in each recorded frame there are 720 pixels in the vertical axis, and 1080 pixels across the horizontal. When you do the math that results in 921,600 pixels in each frame—less than one megapixel! However, when those one-megapixel frames are shown at a rate of 30 frames-per-second (fps), the result is visually stunning.

By default, the camera operates in P mode during movie shooting, but that can be changed in the 🔲 **MOVIE AE MODE** menu (see page 110) to Aperture-Priority mode or any of the six art filters described below (though 🎨, 🎨, and 🎨 reduce the frame rate below 30fps). While the art filters are certainly fun to use, the EP-1 becomes a specialized tool when shooting movies in A mode because of its ability to make very shallow depths of field at wide-open apertures. This ability usually exists only in professional video camcorders, and is a direct result of the larger four-thirds sensor. For more on movie shooting, see page 68.

Art Filters

A special feature recently introduced to Olympus' camera line, Art Filters offer six distinct post-processing techniques that are automatically applied to the image or movie as it is recorded to the memory card. All the Art Filters operate in P mode, and when shooting still images, their effects are applied to only JPEG files; so if you are shooting JPEG only, the effects cannot be reversed. Art Filters can be applied to RAW files in post processing, using the supplied Olympus Master or Olympus Studio software (see page 146).

Pop Art: Boosts the saturation of all colors and gives the image rich, vivid tones. Blacks are also decreased.

Soft Focus: Lowers the saturation and contrast, increases whites, and decreases blacks. Continuous shooting mode is disabled. An excellent mode for portraits.

Pop Art *Soft Focus*

 Pale and Light Color *Light Tone*

 Pale & Light Color: Drastically decreases blacks and contrast while increasing whites. Colors are shifted toward pastels.

Light Tone: Blacks and whites are shifted toward grey, and saturation is decreased across all channels.

Grainy Film: Switches to black and white while drastically increasing whites, blacks, and contrast. Also adds noise (grain) to mimic classic high-ISO films. Continuous shooting mode is disabled.

Pin Hole: Increases blacks and contrast while heavily vignetting the corners of the image. Continuous shooting mode is disabled.

⌧ *Grainy Film* ⌧ *Pin Hole*

Note: Art Filters—particularly ⌧ , ⌧ , and ⌧ — slow down the card-write speeds, resulting in a delay after the image is captured. The LCD screen may also appear to lag as its Live View refresh rate is decreased.

SCN (Scene) Modes

Turn the Shooting Mode Dial to SCN and you'll find a menu offering no less than 19 scene- and subject-specific shooting modes. A sample image is displayed next to each SCN icon, which can be scrolled through using the up-down arrow buttons or either control dial. After a short delay, the sample image will decrease in size and a brief description of the selected SCN mode is displayed. Most of these are self-explanatory, but two are worth a bit more description.

▣ **e-Portrait:** This mode, which softens and smooths over skin tones to hide blemishes, is unique in that it saves two JPEGs simultaneously: one with the effect and one without. Also, it is available during playback after a normal JPEG has been taken via the JPEG Edit function (see page 83).

▣ **Panorama:** This mode overlays a guide to help line up a series of photos that can later be stitched together in Olympus Master or Studio (see page 146) to create a panoramic image. First, press the arrow key in the direction that you'll be moving the camera in between shots. Then shoot the first image, which will lock exposure and focus for subsequent shots (a maximum of ten). The images must slightly overlap each other, for which the blue rectangles at the sides of the LCD serve as a guide.

Don't be afraid of flare. Certainly, there are times where the serious- ▷
ness of the subject requires photographic perfection; but dynamic
street shots like these are less demanding. Here the flare in the left
of the frame helps communicate the dramatic lighting of the setting
sun. 1/500 second at f/8, ISO 200.

Advanced Features and Functions

Shooting Info Screens

By default, the LCD screen shows only the image itself, unobscured by additional shooting information and therefore ideal for delicate compositions, where its 100% coverage really shines. While there are certainly times to use this bare bones Live View approach, a key advantage to Live View shooting is the ability to keep an eye on the subject while simultaneously monitoring any number of additional information screens that can be overlaid on top of the LCD's image. Pressing the INFO button while in a shooting mode will cycle through these Info Screens, each of which is described in detail below.

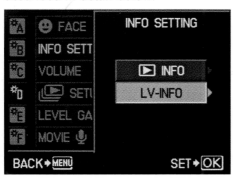

Which shooting info screens are available is determined by the **LV-INFO** option of the **🔟 INFO SETTING** submenu (page 128). By default, all of the shooting info screens are activated except the ▦ and ⊞ Grid Displays.

⟲ Different shooting info screens are optimized for different kinds of shots. For instance, here the Level Gauge screen made sure that the camera was perfectly balance from left to right, fitting the entire scene in frame without too much distortion. 1/160 second at f/5.6,

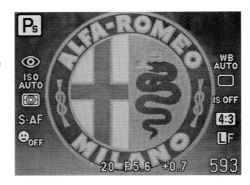

If a lot of settings are changed from their defaults, the screen can start to look a bit cluttered—but you can always revert back to Image-Only view.

The default shooting screen, shown here, displays the shutter speed and aperture at the bottom of the LCD, the shots-remaining counter at the bottom-right corner, and the resolution/image size on the right. If an exposure compensation is set, that is displayed to the right of the aperture. These five values will remain on the screen at all times.

When shooting adjustments are being made, nine additional icons are displayed along the sides of the LCD. This allows you to keep track of all the current settings without having to check them in the menus. If any of these additional settings are changed from their defaults, they too will remain on the screen; otherwise, they will disappear either when the shutter-release button is half-pressed, or after a brief delay.

The Live Histogram

This shooting info screen shows all the information in the default screen, but adds a live histogram above the shutter speed and aperture values. The histogram represents the brightness values currently being captured by the sensor (and displayed in Live View on the LCD): the far left represents pure black, and the far right represents pure white. It follows, then, that most of the histogram should be in the middle range of the histogram. An ideal exposure rises gently from the left, peaking in the middle, and tapering off to zero at the far right—like a gently sloping mountain.

Resist the urge to put a main subject in the center of every frame. Distributing key elements throughout the scene makes for a much more dynamic composition. 1/100 second at f/8, ISO 200.

The ability to see a live histogram of your exposure is one of the major benefits of Live View shooting—and in difficult shooting conditions I cannot recommend this shooting info screen enough. It is best used in tandem with exposure compensation: if the histogram is bunched up at the far left (too dark), dial in a positive exposure compensation until the brightness values are more evenly distributed; and if the histogram leans too far to the right (too bright), a negative exposure compensation will keep your highlights from clipping.

Grid Displays ⊞ ⊞ ⊞

These three shooting info screens are compositional aids. The Scale display ⊞ overlays a crosshair that makes it easy to target a subject exactly in the center of the frame. The ⊞ display splits the LCD into 20 separate squares, and is useful for both delicate macro work and architectural shots—when there are numerous vertical and horizontal lines that must be lined up relative to each other.

The ↕ display divides the LCD into nine distinct areas, making it easy to adhere to the Rule of Thirds. In this classic technique, important subjects do not occupy the center of the frame, but rather lie along or at the four intersections surrounding the center of the frame. The idea is that this uneven distribution across the frame creates a dynamic tension that wouldn't be present in a head-on shot.

Here you can see how much easier it is to check focus by using the zoom view on the right which magnifies the area in the green rectangle on the left.

Zoom View

In this shooting info screen, a small green rectangle is displayed in the center of the frame. This can be moved anywhere on the screen using the ✤ buttons; then, by pressing the ⓞⓚ button, the LCD will show a 7x magnification of the area where the rectangle was positioned. Turning the subcommand dial to the right increases this to a 10x magnification. At these levels of magnification, it's a breeze to

either confirm that the autofocus system hit its mark, or use precise manual focus. Once focus is achieved, you can press the ⊛ button again to return to normal 1x magnification, or press the shutter-release button to capture the shot—though it's worth noting that there is a slight increase in shutter lag if the shutter is fired directly from zoom view.

As discussed on page 53, this is the best way to guarantee accurate manual focusing when using third-party lenses. Micro or Regular Four Thirds lenses can benefit from the MF Assist function described on page 117, which largely renders this function obsolete for manual focusing. It is still, however, an extremely useful tool in macro work, when you have the time to fine-tune focus.

Note: In this shooting info screen, the dedicated functions of the 🔲 buttons are deactivated (because they are used to move the zoom rectangle). The Live Control Menu and Super Control Panels are also deactivated (because the ⊛ button is used to engage the zoom view). Therefore, it's best to adjust all the relevant camera settings in another shooting info screen first, and then switch to Zoom View for focusing.

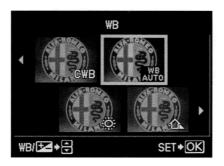

Effect Preview

This shooting info screen displays four miniature windows, each showing identical views but with different exposure compensation or white balance values. Pressing the left or right buttons cycles through a greater range of values, and pressing up and down switches between exposure compensa-

tion preview and white balance preview. Pressing the 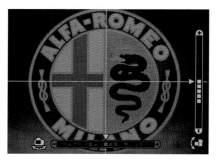 button will set the currently-selected effect, and return to the default shooting info screen. Because the previews are significantly reduced in size, this feature isn't particularly useful for shooting-on-the-fly; but if you have a minute to evaluate the different previews, it does save you from having to guess and test until you hit the right exposure.

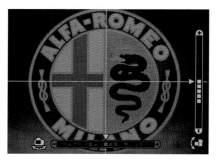

The Level Gauge

Another compositional aid, the level gauge helps keep the camera parallel to both the ground and horizon line by displaying the degree of left-right tilt (roll) or front-back tilt (pitch). Beautifully simple, the two bars running along the bottom and right side of the LCD will glow green when the camera is perfectly balanced; if the camera detects a tilt, a line of white pixels will extend in the opposite direction of the tilt, just like an air bubble does in a traditional carpentry level. When the horizontal pixels extend to the right, tilt the camera to the right; when the vertical pixels extend upward, tilt the camera up. When both axes are green, fire the shutter release!

In critical macro work or wide-angle architectural photography, wherein even the slightest tilt can dramatically alter the composition, this feature is a godsend. It is particularly useful in controlling the keystone effect—a form of distortion in which parallel lines appear to converge, and tall objects seem to be falling backward. As long as the vertical level is green, there shouldn't be any keystoning (assuming the subject is also perpendicular to the ground).

Keystoning, when controlled, can be a powerful tool in composition. 1/1000 second at f/8, ISO 200.

Note: If, over time, you notice the level gauge to be inaccurate, see page 142 for directions on resetting it to a neutral position.

ISO

ISO measures the sensitivity of the sensor, and can be set from 100 to 6400 in intervals of 1/3EV (the interval can be adjusted to 1EV in the ⚙ **ISO STEP** submenu—page 132). At lower ISOs, the sensor is less sensitive to light and the image contains less noise; higher ISOs generate more noise as a side effect of being more sensitive to light. Greater sensitivity means higher shutter speeds and narrower apertures are possible in less light.

The E-P1's imaging sensor is calibrated for ISO 200. This means that at ISO 200 you have maximum dynamic range and color accuracy while maintaining negligible amounts of noise. Increasing the ISO allows you to shoot at faster shutter speeds and wider apertures in low-light situations, at the cost of decreased dynamic range and increased noise. That said, higher ISOs are one of the main benefits of an SLR-sized sensor; and in most situations you can comfortably shoot up to ISO 1600 without worrying too much about noise—quite an accomplishment, due in no small part to the E-P1's new DIGIC IV imaging processor.

The easiest way to adjust the ISO is by pressing the dedicated ⓘ button, which calls up a row of ISO settings along the bottom of the LCD (though this is not available in Zoom or Effect Preview shooting info screens). Simply highlight the desired ISO and press either the ⊚ button or half-press the shutter release to return to shooting mode. ISO can also be adjusted in the Live Control Menu or the Super Control Panel—and this is the only way to adjust ISO if the ⓑ ⌨ **FUNCTION** submenu is set to **OFF** (page 125).

AUTO will make the camera automatically adjust the ISO based on the subject's brightness, and the ISO range from which it can choose is set in the ⓔ **ISO-AUTO SET** submenu (page 132). The high limit for the **AUTO** ISO range can go as high as 6400, but I caution against this, as the camera will always favor a high ISO over a low shutter speed, even if that shutter speed is capable of producing a sharp image with the Image Stabilization system. 1600 is a more reasonable high limit.

Note: ISO cannot be adjusted in **iAUTO**, ⌘ Mode, or any SCN modes. These shooting modes always use **AUTO** ISO.

Digital Noise: The rough equivalent of film grain, digital noise results when the electronic signal from the sensor loses quality, due to either heat from longer exposures or increased amplification from higher ISOs. There are, therefore, two different ways to compensate for the appearance of noise in your images. The 🅱️ **NOISE REDUCT**. menu item is designed to eliminate the first kind of noise, resulting from longer exposures—see page 135 for details. The 🅾️ **NOISE FILTER** menu item (page 136) is designed for use with higher ISOs.

What setting you select for the Noise Filter (Off, Low, Standard, or High) is a matter of personal taste. Off and Low will get you the maximum amount of detail, and are best for general shooting under ISO 800. Standard and High will keep noise levels very low, at the cost of smoothing over areas of fine detail. Generally, I recommend either Low or Standard. Of course, shooting RAW allows you to adjust the Noise Filter at your leisure in post processing.

White Balance

Not all light is the same; for instance, sunlight has a blue tone and a higher color temperature, while a tungsten lamp has a yellow tone and a cooler color temperature (counter-intuitive, I know). The human eye automatically adapts to these variations in the color of light, making sure that red always appears red and blue appears blue. But digital cameras have a harder time of it. They require a point of reference, an area of white or neutral gray, off of which all the other colors in the scene can be based—or balanced. Thus, the color temperature of a scene is referred to as the White Balance (WB).

The E-P1 can balance the colors of a scene in one of three ways: automatically with its **AUTO** ISO function (which seeks to emulate the human eye—though not always so successfully); according to a preset temperature typical of the current light source; or manually, by either dialing in an

exact color temperature in degrees Kelvin (Custom White Balance—**CWB**) or by directing the camera at a white or 18% gray area and identifying it as such to the camera (One-Touch WB— 🔄).

The easiest way to adjust the WB is by pressing the 🔘 button, which calls up a row of eight WB presets in addition to the two manual white balance options and the **AUTO** WB function. Simply highlight the desired WB option, and then either press the 🔘 button or half-press the shutter release. The specific color temperatures of each preset are shown below.

☀	⛰	☁	☀	🔆1	🔆3	🔆3	WB⚡
5300K	7500K	600K	300K	400K	4500K	6600K	5500K

If the current scene lacks any white or neutral gray tones then the AUTO WB will almost certainly be skewed. This is most apparent under artificial light. In any case, just keep an eye on your images' colors as they appear in playback; if they appear incorrectly balanced, then choose a preset or one of the manual WB settings.

To set a **CWB** value, highlight the **CWB** icon, press and hold down the 🔲 button, and scroll through the settings using either command dial or the left-right arrow keys. You can select temperatures from 2000K to 14000K, in varying increments. The effects of the various color temperatures will be displayed in Live View on the LCD; when the colors appear accurate, release the 🔲 button and either press the 🔘 button or half-press the shutter release.

One-Touch WB: As described above, this WB setting directly informs the camera what color is objectively white (according to your human eye), allowing it to balance all the colors accordingly. But before a One-Touch WB can be recorded, the 🔲 [Fn] **FUNCTION** submenu must be set to 🔄 . Next, compose a shot in which a white or neutral (18%) gray subject fills the entire frame of the LCD. Then, hold down the [Fn] button and simultaneously fire the shutter. If the

capture is successful, you'll be prompted with a confirmation dialogue. Press YES, and the color temperature of that particular light source will be saved to the ⬚ WB setting. If **WB NG RETRY** appears next to a large, red X, then recompose the shot in better lighting, making sure that no shadows are falling on the subject, and that it is evenly lit across the frame.

Note: WB settings apply only to the JPEG file format; if you are shooting RAW, you have 100% flexibility over white balance in post-processing. Therefore RAW is really the best solution to troublesome or constantly changing lighting conditions. You will still be able to set the WB while shooting in the RAW format, but during RAW processing that white balance will simply be the "As Shot" setting, and can be changed without any degradation of image quality.

Drive Modes ⬚ ⬚ ⬚ ⬚

By default, the EP-1 will capture one image with each full-press of the shutter release; but it can also be set to sequentially shoot three frames-per-second (fps) while the shutter release is held down, or it can start a timer of two or twelve seconds. Press the ⬚ button to call up these options along the bottom of the LCD screen, scroll through them using either command dial or the left-right arrow keys, and press the ⬚ button when your desired setting is highlighted.

Single-shot ⬚ drive mode will take only one shot, and the shutter-release button must be pressed again in between each capture. This is the best drive mode for normal shooting. Continuous ⬚ drive mode will fire the shutter automatically as long as the shutter-release button is fully pressed, and is excellent for capturing action shots, or any subject that is constantly changing. In **S-AF**, **MF**, and **S-AF+MF** focus modes (described below), the exposure, white balance, and focus for the continuous series is determined by the first shot; after that, those settings will be applied to

all subsequent shots. The camera can capture and record three frames per second (fps) of either twelve Large Fine JPEGs or five RAW images; after that buffer is filled, the fps rate will drop, depending on the speed of the memory card in use. When ⃞ is used in C-AF focus mode, the camera will re-focus and reset the exposure in between each shot, which decreases the frame rate considerably.

⌚ is a two-second timer; when the shutter release is pressed, the self-timer LED on the camera's front will blink for seconds and then the shutter will fire. Because two seconds is not much time to run in front of the camera and pose for a group shot, ⌚ is more useful as a means to stabilize the camera during long exposures, as it prevents camera movement resulting from the shutter release being pressed.
⌚ mode is a twelve-second timer that is much more useful for getting into group shots. When the shutter release is pressed, the self-timer LED will stay lit for ten seconds, and then blink for the last two.

Note: Each drive mode can be delayed by the ▣ **ANTI-SHOCK [♦]** menu item, described on page 133.

Focus Modes

Pressing the ⊚ button calls up four icons on the bottom of the LCD, which can be scrolled through using either of the command dials or the left-right arrow buttons, and selected by pressing the ⊚ button or half-pressing the shutter release.

S-AF: The default focus mode, Standard Autofocus is activated by a half-press of the shutter-release button, and uses the selected AF area (see below) as a target. If all eleven AF areas are selected, the camera will focus on the area with the highest contrast. Once focus is achieved, a green light will appear in the upper right of the LCD and the camera will emit a confirmation chirp. If that green light blinks, that means the autofocus failed and the camera will not fire the

shutter even if the shutter-release button is fully pressed. To override this function and force the shutter to fire regardless of focus confirmation, activate the **⬛C RELEASE**/ 🔁 menu item (page 125).

C-AF: As long as the shutter-release button is half-pressed, the camera will constantly scan all eleven AF areas in an attempt to track a moving subject. To best use this focus mode, frame the moving subject, half-press the shutter button, and keep the subject in frame until the peak moment of action, or until the composition is ideal; then fully press the shutter button. As described above, when **C-AF** is used in conjunction with Continuous 🔁 Drive mode, the camera will re-focus in between each shot.

Note: Only Micro Four Thirds lenses can use C-AF.

MF: Manual Focus mode requires manual adjustment of the lens' focus ring, and does not assign any focus operation to a half-press of the shutter-release button. The **AEL/AFL** button can, however, be customized to activate **S-AF** via the **⬛B AEL/AFL** menu item (see page 118).

Because it can be difficult to evaluate critical focus on the LCD screen alone, there are two options available to assist by zooming into the scene: the Zoom View shooting screen described on page 44, and the **⬛B MF ASSIST** menu item described on page 117. Zoom View is most useful in tripod and macro work, as it is more cumbersome but allows you to both adjust the area to be magnified and also increase magnification from 7x to 10x. MF Assist automatically zooms in as soon as the focus barrel is rotated, and functions during any of the shooting screens, so it's better suited for on-the-fly manual focusing. However, MF Assist only works on Micro and Regular Four Thirds lenses.

S-AF+MF: This focus mode combines **S-AF** and **MF**, by first autofocusing when the shutter release is half pressed, and then allowing manual focusing so long as the shutter release is held in its half-pressed position. If **S-AF** is hit-or-miss, say

What the CDAF system lacks in responsiveness, it more than makes up for in accuracy. When the little green AF confirmation dot appears in the LCD, you can rest assured the focus is spot-on. 1/50 second at f/4.5, ISO 400.

in a dim, low-contrast scene, this is when **S-AF+MF** comes in handy. If and when the autofocus fails, you can still manually focus and take the shot without having to switch from **S-AF** to **MF**. The shutter will fire when the shutter-release button is fully pressed, regardless of autofocus confirmation.

[∷∷] AF Areas

As mentioned earlier, the EP-1 has eleven AF areas spread across the center region of the frame, each of which can be set as the target on which the autofocus system will attempt to achieve focus. When [∷∷] is selected in the Live Control Menu, the camera will evaluate all elevate AF areas and focus on the closest one with the most contrast. By choosing

the easiest area it is more likely to achieve focus quickly, but you have no control over which AF area it will choose; it may focus on the table right in front of the camera rather than the distant scene through the window. Selecting **[•]** prompts you to select just one of the eleven AF areas, which will be highlighted in green.

In general, this is best left at the center AF area, which then facilitates easy focus lock (page 20). However, in tripod and macro work, where it is not so easy to recompose the shot, it is extremely useful in specifying the specific area on which the camera should focus.

☻ Face Detection

A relatively new method of autofocusing that is quickly becoming standard across all consumer digital imaging technology, Face Detection runs an algorithm in tangent with the Contrast Detect Autofocus (CDAF) system that distinguishes a human face in the frame, then isolates that face as the main subject on which to focus. When engaged, Face Detection automatically changes a number of other functions to facilitate its focusing method: metering is set to **ESP**, gradation is set to **AUTO**, focus mode is set to **S-AF**, and all eleven **AF** areas are selected.

Metering Modes

Metering is the process by which a scene's brightness is measured, so that a corresponding exposure can be set (by some combination of shutter speed, aperture, and ISO). There is no dedicated button for adjusting the metering mode, so it must be reached either via the Live Control Menu or Super Control Panel, or by mapping the �«» button to the **METERING** function in the 🄱 �«» **FUNC-TION** submenu (page 122).

▣ ESP (Electro Selective Pattern)

In this metering mode, the camera measures the brightness of 324 separate areas of the imaging sensor, evaluates the differences among various regions of the frame, and then calculates an exposure that (to the best of its ability) balances the variety of tones to accurately render the entire image. It is designed for general-purpose shooting of evenly lit scenes.

◉ Center-Weighted Average

This mode distinguishes between the center 10-15% of the frame and the surrounding remainder, and then calculates an average between the two while giving a preference toward the center. It is different from Spot metering in both the size of the center region and that it still measures the entire frame. This is excellent for portraits in difficult lighting, as it does not allow the background to interfere with the exposure of the main subject.

◉ Spot

Here only a relatively miniscule portion of the exact center of the frame is measured and completely disregards the surrounding area. A specialized tool, meant for dealing with particularly difficult lighting situations, Spot metering excels at combating strong backlighting that would otherwise cause an overexposure. It is most effective when combined with Autoexposure Lock (**AEL**—see next page).

Highlight Control: Bright, pure white subjects are difficult for metering systems to manage because there is not enough contrast them for the to establish black and white reference points, and so a snowy day will often be rendered a pale, neutral gray. This specialized metering mode measures the same small area as Spot metering, but intentionally overexposes the shot in order to render whites white.

Shadow Control: The exact inverse of highlight control, shadow control intentionally underexposes an exceptionally dark subject that would otherwise be rendered gray due to the lack of sufficient tonal reference, resulting in an accurate rendering of blacks.

Autoexposure Lock (AEL)

The top button to the right of the LCD is the autoexposure lock/autofocus lock (**AEL/AFL**) button. By default, pressing and holding this button will lock the current exposure, allowing you to recompose the scene without changing the brightness level. A highly customizable button, it can also be set to lock exposure with one touch (without being held down), engage the current autofocus mode, or even have its function switched with the ⬛Fn button. For customization options see pages 118-119 on the 🔳 **AEL/AFL** submenu.

Image Stabilization

Mentioned in the introduction, the sensor-shift image stabilization system is a headline feature of the EP-1, offering automatic stabilization for shutter speeds as low as two seconds. It can be activated in the Live Control Menu and Super Control Panel, or in the 🔳 **IMAGE STABILIZER** submenu. The IS system compensates for camera shake on both a vertical and horizontal axis when set to **IS1** mode. But its functioning can interfere with a photograph technique called panning, wherein a somewhat longer shutter speed is employed while tracking a subject moving perpendicular to the camera. This results in a sharp subject cast against a blurred background, and effectively communicates action and movement. To track a moving subject while holding the camera horizontally (in landscape orientation), switch to **IS2** mode, which deactivates only the horizontal stabilizer. It follows that if the camera is held vertically (in portrait orientation), **IS3** mode is best because it deactivates the vertical stabilization. If you're using a tripod, any form of image stabilization can be counterproductive, so deactivate the IS system entirely by switching to **IS OFF**.

A major advantage of sensor-shift image stabilization is that it can be used with any lens, even a decades-old manual focus one. Micro and Standard Four Thirds lenses will be automatically detected and stabilized, but third party lenses

must have their focal lengths input manually. To do this, scroll to the IS icon of the Live Control Menu and simultaneously rotate either control dial while holding down the ⚡ button until the lens' focal length appears at the bottoms right of the LCD. The most common focal lengths from 8mm to 1000mm are available; if your lens' focal length is missing, just choose the closest value possible.

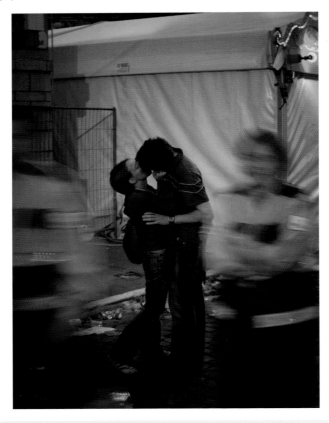

Caution: *If you are using a third-party lens that is itself stabilized, the lens' stabilization system will interfere with the sensor shift system; you must choose which system to use, and deactivate the other.* © **Sven Thierie**

Note: It took a lot of engineering to shoehorn such a power-ful stabilization system into a compact body, and it shows: That buzzing hum you hear and feel while taking a stabilized shot is the IS system operating. You'll experience the same mechanical noise when turning the camera on, as it must initialize to prepare for use. None of this is out of the ordinary; should something in fact go awry, the system will deactivate and a red **IS** icon will blink on the LCD—this would most likely be the result of overheating, in which case the camera needs to rest and cool off for a while.

Aspect Ratio

Here you'll find four different aspect ratios at which the EP-1 can record images. Make no mistake: the sensor's native aspect ratio is 4:3, and any other aspect ratio is merely a crop that reduces resolution. Also, there is an in-camera crop function under the JPEG Edit function (page 83), making it even easier to shoot at full resolution and crop later—with greater precision. That said, 12 megapixels provide plenty of room for cropping, and cropped Live View image displayed on the LCD is useful for visualizing the composition in a certain aspect ratio. RAW images retain their full resolution and merely save the crop as part of their imbedded JPEG.

The aspect ratio can also be set in the Live Control Menu or Super Control Panel, but the 🔲 **IMAGE ASPECT** menu item (page 109) additionally displays the pixel resolution of each different aspect ratio at each file format—and even displays this information next to the full four-thirds resolution. That information is reproduced here.

	RAW	Large	Middle	Small
4:3	4032x3024	4032x3024	2560x1920	1280x960
3:2	4032x3024	4032x2688	2544x1696	1296x864
16:9	4032x3024	4032x2272	2560x1440	1280x720
6:6	4032x3024	3024x3024	1920x1920	960x960

The 16:9 format feels unusual at first, as it is not a standard aspect ratio for most still-image photography. But you'll find it is ideally suited for some subjects, and often fits perfectly on modern computer screens. 1/30 second at f/8, ISO 200.

File Formats

The E-P1 can record two types of files: RAW (in Olympus' proprietary .ORF format) and JPEG (Joint Photographers' Expert Group—a universal standard for image files). RAW files contain the complete information captured by the sensor, at full 4032x3024 resolution without any compression or loss of data. As a result, RAW files cannot be viewed or printed right away, and must first be processed (either in camera—page 82—or in post processing software like Olympus Master— page 146). In exchange for this extra step of processing, RAW files give a great degree of flexibility in post processing, particularly regarding white balance (see page 49).

JPEGs are processed in-camera, and are thus immediately available for viewing or printing. They can be processed at three different resolution settings, and at four different levels of compression. Large JPEGs always record at full 4032x3024 resolution; the resolution for Medium and Small JPEGs can be customized in the 🔧 **PIXEL COUNT** sub-

menu (page 138). Additionally, the ▣ ◄▪ SET sub-menu (also page 138) determines which combinations of resolution and compression appear as options in the Live Control Menu and Super Control Panel. The table below shows the twelve different combinations of resolution and compression available in 4:3 aspect ratio JPEG shooting, with the file size of each combination expressed in megabytes (MB), and the number of each file type that can fit onto a 1GB SD/SDHC card.

	Large (4032x3024)	Medium (2560x1920)	Small (1280x960)
Super Fine (1/2.7)	8.4MB (101/GB)	5.6MB (154/GB)	0.9MB (1044/GB)
Fine (1/4)	5.9MB (145/GB)	3.4MB (255/GB)	0.6MB (1514/GB)
Normal (1/8)	2.7MB (320/GB)	1.7MB (504/GB)	0.3MB (2884/GB)
Basic (1/12)	1.8MB (470/GB)	1.2/MB (747/GB)	0.3MB (4038/GB)

Each of the other three possible aspect ratio results in another set of twelve combinations, but since they are all crops of the 4:3 ratio, it follows that file sizes decrease accordingly.

Note: The SuperFine compression setting is deactivated by default, and can only be accessed in the ▣ **PIXEL COUNT** submenu described above.

Picture Modes

Picture modes determine how the RAW data is processed into JPEGs, and are accessed in either the Super Control Panel or in the **📷 PICTURE MODE** submenu. Each of the first four Picture Modes can have their **RGB** Saturation, **©** Contrast, and **ⓢ** Sharpness fine-tuned in increments of +/-2.

🏔 Vivid: Boosts saturation across all the color channels, rendering colors richer and bolder than they appear in reality.

🏔 Natural: Renders colors as accurately as possible, with minimal saturation and contrast.

🏔 Muted: Decreases saturation, contrast, and sharpness, rendering a subdued image that is then more easily tweaked in post processing.

🏔 Portrait: Skin tones are given priority, ensuring that faces do not appear too red or too pale. Contrast is also increased.

📜 Gradation

Another adjustment available in each of the above Picture Modes is **📜** Gradation, which determines how the image will render the bright and dark regions of the image. For most shooting, keep this setting on **📜 NORM**, which balances dark and bright regions equally, and keeps noise levels at a minimum. **📜 HIGH** will shift the JPEG's tone curve to the left, keeping shadows dark and making sure the camera doesn't overexpose highlights. **📜 LOW** shifts the tone curve to the right, bringing up shadow detail without regard for highlights. **📜 AUTO** is similar to the **Shadow Adjustment** JPEG EDIT option (page 84), in that it attempts to bring up shadows and pull back highlights in order to maximize the dynamic range in the image. I don't recommend using **📜 AUTO**, as it will often unnecessarily introduce noise into the shadow regions of images.

Monotone

Here the camera renders a black-and-white image (which should be called monochrome, not monotone), with fine-tuning options for Sharpness and Contrast. There is no Saturation fine-tuning (obviously, because there is no color), nor is there an option to change the ✐ Gradation (which remains set to **NORM**). In place of these adjustments (in both the Super Control Menu and the ◻ **PICTURE MODE** menu) are ⓕ **B&W FILTER** and ⓣ **PICT. TONE**.

ⓕ **B&W FILTER:** The monochrome image can be rendered normally (**N:NEUTRAL**), or it can emulate the use of one of four filters: **Ye:YELLOW** will brighten oranges and reds while darkening blues; **Or:ORANGE** is a stronger version of a yellow filter, and can help eliminate haze and fog; **R:RED** dramatically darkens blues to almost black and significantly increases contrast; and **G:GREEN** will lighten foliage and soften skin tones of portraits. The effects of these different filters can sometimes be hard to predict; fortunately, you can use the Live View image to quickly determine which filter is the most appropriate for a particular subject.

ⓣ **PICT. TONE:** For a monochrome image, this must be set to **N:NEUTRAL**; the other four options (**S:SEPIA**, **B:BLUE**, **P:PURPLE**, or **G:GREEN**) will shift the color of the image toward that respective color, rendering a monotone image (the correct use of the term).

Custom Picture Mode

In the **CUSTOM** option of the ◻ PICTURE MODE menu, you can make fine-tuning adjustments to any of the above described Picture Modes, and then save them to a **CUSTOM** Picture Mode, which can then be accessed via the Super Control Panel. This can be useful if you find yourself frequently making the same adjustments to a single Picture Mode—though I wouldn't spend too much time obsessing over these small details. Remember, if you shoot in the RAW format, you can always apply these settings retroactively (see In-Camera Editing, page 82).

The golden hour, be it during a sunrise or sunset, can give a scene an unmatched quality in its warm hues and long shadows. © Sven Thierie

Color Space

The camera has two different ways of recording the color values of an image: sRGB and Adobe RGB. Unless you have a specific reason for using the latter—namely, certain industrial applications—you should always leave this on sRGB. sRGB is by far the most commonly used color space, and therefore keeps your colors consistent across different computers, printers, and particularly web pages. If you find that your images look differently as they are uploaded to the Internet, double check that sRGB is set for their color space, as this is a common cause of inaccurate colors.

Multiple Exposures

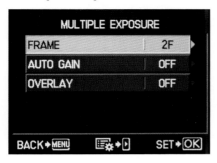

In **P**, **A**, **S**, or **M** modes, this feature allows you to overlap two images, combining them into one single image. First, go to the ₂ **MULTIPLE EXPOSURE** menu option, highlight **FRAME**, and select **2F**. Now, when you return to the current shooting mode, a 🔲 icon will be displayed in the bottom left of the LCD. Compose and capture an image as usual. That image will then be overlaid on top of the Live View image on the LCD during the next shot. Line up the next shot with respect to the previous one, and fully press the shutter-release button. The two images will be combined and saved as one single image.

If **AUTO GAIN** is deactivated, the intensity of each shot with respect to the other will depend on their respective exposures. That is to say, if one shot is underexposed by 1EV, and the other shot is overexposed by 1EV, then the latter will be much more apparent in the final, combined exposure. If **AUTO GAIN** is activated, the camera will equalize the combined exposure to evenly balance both shots, regardless of whether one is brighter or darker than the other.

By activating the **OVERLAY** option, you can browse through all the RAW images currently saved to the card and select one to add a second exposure to. The RAW image you select will then be overlaid on the Live View display; at that point you can compose a second exposure, capture it, and they will be combined as described above.

Note: The **IMAGE OVERLAY** option in the ▶ **EDIT** menu allows you to create multiple exposures out of saved RAW files in Playback—see page 82.

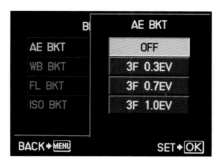

Bracketing

Bracketing entails taking a series of images, each with a different setting applied. This useful tool is inconveniently buried under the **BRACKETING** option on page 2 of the 🖼 EXP/ 📷 /ISO menu (page 134). It is best used in conjunction with Continuous 🔁 Drive mode.

AE BKT (Autoexposure Bracketing), **FL BKT** (Flash Bracketing), and **ISO BKT** (ISO Bracketing) all have the same menu options: three frames in a series, with each frame varying by 0.3EV, 0.7EV, or 1.0EV. This means, for instance, that if **AE BKT** is set to **3F 1.0EV**, then the first exposure in the series will be taken with a normal exposure, the second will be underexposed by -1.0EV, and the third will be overexposed by +1.0EV. **AE BKT** achieves this with exposure compensation (page 27), **FL BKT** uses flash exposure compensation (page 103), and **ISO BKT** simply sets a different ISO for each exposure. These three types of bracketing are all useful in scenes where the exposure is difficult to measure accurately, or if there is simply too much dynamic range to fit all the brightness values of the scene into one single exposure. In the case of the latter, the three images can be combined into one high dynamic range (HDR) image in post processing.

Note: The EV increments available for bracketing are determined by the 🖼 EV STEP menu (page 131).

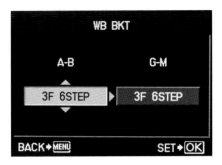

WB BKT (White Balance Bracketing) works differently. Only one shot is taken, and the camera creates a bracketed series by processing it different ways. The exposure remains constant, but the white balance is adjusted along two axes: amber-blue (**A-B**) and/or green-magenta (**G-M**). The adjustments are based off of the current WB setting, and will deviate up or down along their respective axes by 2, 4, or 6 steps. And the two axes operate independent of each other, so if both **A-B** and **G-M** are set for brackets, each will record a separate series of three images. Needless to say, WB bracketing is absurdly complex, and will take up a large amount of room on your memory card. If you are ever in a situation with lighting so complex that a bracket of a half dozen different shots or more are necessary, I recommend simply shooting RAW and dealing with it in post processing.

Movie Shooting

The E-P1 can record both high- and standard-definition movies in the Motion JPEG (M-JPEG) format. These files are saved as .AVI files, and can be played on most common video players. The resolution can be set to either **SD** (Standard-Definition, 640x480) or **HD** (High-Definition, 1280x720) via the 📷 ◀⋮- MOVIE submenu. The difference between these resolutions is noticeable, and while Standard-Def might save some space on your memory card, you'll really be missing out on some stunning detail. On that note, it's worth repeating that for best performance you

should be using a Class 6 SDHC card. The size of the video file is limited to 2GB, after which recording will automatically stop; this does not set an exact time limit on the length, but it's usually around seven minutes. Sound is also recorded in stereo and saved with the video file, though this can be deactivated in the ▣D MOVIE🎤 submenu.

The E-P1 does have to sacrifice a number of its features in order to record movies of this quality. The Image Stabilization system is deactivated—though replaced with a digital version that attempts to keep the scene level by cropping out a small amount of the outer frame (thereby reducing the angle of view by a small amount). This works, but not as well as the mechanical stabilization system that you're used to from shooting stills, so it is very important to keep the camera as level and still as possible. If you are going to pan from side to side, do so very slowly and with an even hand. However, if you are using a lens that has a built-in stabilizer function, you can employ its use to great effect.

ISO is also locked at **AUTO**, which can cause the quality of the movie to drop in low light; therefore it's best to use wide apertures in dim lighting conditions. Metering mode is locked at ▣ **ESP**. Obviously, Continuous 🖳 Drive mode is not available, but both self-timers can be used. You also have complete control over the white balance (page 49), though the presets cannot be adjusted once recording begins.

Just like still-image capture, movie recording is begun by fully pressing the shutter-release button, and ended by a second full-press. Half-presses have no effect once recording begins. You can set the camera to record a full-resolution still image at the very end of a movie by activating the ▣₂ **MOVIE+STILL** option.

Movie Shooting Modes

In the 🎬₂ **MOVIE AE MODE** menu option, you can select which shooting mode to use during movie recording. By default, the camera will shoot in P mode, automatically determining the best aperture and shutter speed (which must be above 1/30 second). It will also record in P shooting mode while any of the Art Filters are used. The Art Filters can be a lot of fun, and definitely provide your movies with a distinctive look without having to do intensive post processing. 🎨₂ , 🎨₅ , and 🎨₆ reduce the frame rate below 30fps, but don't let this discourage you from experimenting with these Art Filters, as the lower frame rate can add be an interesting artistic touch. In A mode, you can select the aperture, which will stay locked throughout the movie recording. If you are filming moving subjects, it helps to set this to a narrow aperture (higher f/stop), as it will expand the depth of field and keep subjects in focus, without actually having to refocus the shot. Wide apertures (lower f/stops), on the other hand, can dramatically blur out the back- or foregrounds to emphasize one particular subject. I strongly recommend playing around with all of these different modes and options, as the possibilities are quite endless.

Exposure will be automatically adjusted using 📷 **ESP** metering mode, and cannot be changed once recording begins. You can, however, set an exposure compensation before shooting begins, which will be maintained throughout the shot.

Move Focus Modes

All focus modes remain available while recording movies (though 😊 **Face Detection** is deactivated). In **S-AF** mode, the camera will lock focus as soon as the shutter-release button is pressed, and will re-focus any time the **AEL/AFL** button is pressed. In **C-AF** mode, the camera will automatically attempt to refocus whenever it detects subject motion, or if the scene is recomposed around a new subject at a different distance. In **MF** mode, obviously, you have complete control over the focus. It's worth noting here that the stereo micro-

The Olympus Master software offers some basic movie editing options, like single-frame extraction, splicing, and face-in/fade-out transitions. 1/125 second at f/5, ISO 200.

phones will pick up most any sounds made by the camera, including its zooming and focusing operations (even manual focus—because this operates by electronic fly-by-wire, see page 116).

Playback and Editing

Pressing the ▶ button while in any shooting mode or the menu system will switch the LCD screen to Playback mode, which accesses the image and movie files that have been saved to the memory card. These files can then be displayed in one of five different playback views, magnified to check focus and detail, deleted from the memory card, or even edited and processed into new JPEG files. To cycle through the images and movies, use the four arrow keys: left moves to the previous shot, right advances to the next, up jumps ten frames back, and down jumps ten frames forward. The first and last image stored images are linked, meaning that pressing the right-arrow button while at the last image will jump to the first, and the left-arrow button will jump from the first image to the last. Pressing the ⊠ button rotates the image clockwise 90 degrees.

Playback Views

Pressing the INFO button will cycle from one playback view to the next, in the order that they are presented below. To exit any of these modes, press either the ▶ button or half-press the shutter release. The current playback view will be saved, and will automatically be called up the next time the ▶ button is pressed.

↩ *When you look at all the post-capture options available in the E-P1, it takes on the personality of a capable multimedia system. With editing functions, sound recording, TV playback, and direct printing, the camera can almost render your computer obsolete! 1/500 second at f/8, ISO 200.*

Image-Only

Here the image or movie frame fills the entire image, appearing without any additional information. This makes it easy to evaluate the composition as a whole.

Simplified Info

This view displays the date and time of the captured shot at the bottom left of the screen, as well as the resolution, compression, aspect ratio, file format, file name, and sequence number on the card. This sequence is always consecutive, meaning that if an image is deleted, the sequence numbers of all the shots taken after it are decreased by one. Note that the file name remains constant, regardless of its sequence on the card.

Detailed Information

As shown, this view shows a great deal of information about the subject, at the cost of reducing the size of the image itself by 1/4. This mode is invaluable during critical shooting, as it shows which settings achieve which results—particularly when using any of the camera's automated functions. For instance, there is no way to know ahead of time which ISO the camera will select when it is set to **AUTO ISO**; you have to check the image in this playback view to find that out.

Histogram

As discussed on page 42, the histogram is an invaluable tool for checking accurate exposure. Here you can decide if an exposure compensation needs to be made, particularly when over- or underexposure isn't readily apparent from the image itself as displayed on the LCD. For instance, when viewing the LCD in direct sunlight, even if the image details and colors are washed out, you will probably still be able to make out the histogram.

Highlight & Shadow

The histogram view described above can show you when highlights or shadows are clipped, but they won't show the location of those blank areas in the image. For that, switch to this mode: Regions of the image with blocked up blacks

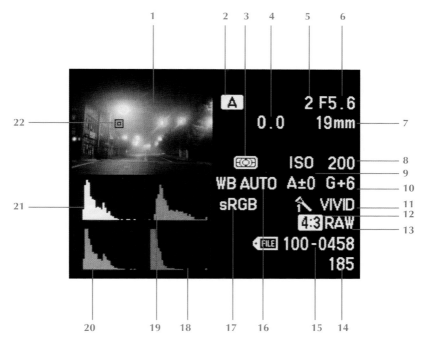

1. Recorded Image
2. Shooting Mode
3. Metering Mode
4. Exposure Compensation
 ⊡
5. Shutter Speed
6. Aperture
7. Focal Length
8. ISO
9. Amber WB Fine Tuning
10. Green WB Fine Tuning
11. Picture Mode

12. File Format
13. Aspect Ratio
14. Sequence Number
15. File Name
16. White Balance
17. Color Space
18. Blue Channel Histogram
19. Red Channel Histogram
20. Green Channel Histogram
21. Total Brightness Histogram
22. AF Area

will flash blue, and clipped highlights will flash red. If you find you need to re-shoot, spot metering is an excellent companion, as it allows you to pick exactly which area of the frame on which to judge exposure.

Magnified View

In any of the above playback views, rotating the subcommand dial to the right (toward the Q icon) will zoom into the currently displayed image in increments of the following magnifications: 2X, 3X, 5X, 7X, 10X, and 14X. The magnification ratio is displayed at the bottom left, and four green arrows on each side of the LCD indicate that you can pan across the image using the arrow keys. To return to the current playback view, either rotate the command dial back to the left or press the ⊛ button.

☻ **Face Detect Check:** If ☻ Face Detect (page 55) was active at the time the currently displayed image was taken, and is still active in the current shooting mode, pressing the **Fn** button twice will zoom in directly on the face used to achieve focus. If multiple faces were detected, pressing the up-down arrow keys switches between these while maintaining the level of magnification. When ☻ was not used or is not currently active, pressing the **Fn** button will simply display a green rectangle on the image that can be moved to anywhere on the screen, and then zoomed into 10X with a second press of the **Fn** button.

Index & Calendar View

From any playback view, rotating the subcommand dial to the left (toward the ▦ icon) will display multiple smaller images on the LCD simultaneously. 4, 9, 16, 25, 49, or 100 images can all appear together, depending on how far left the dial is rotated. This makes it easy to quickly cycle through a large number of images.

At the seventh click of rotation (past 100-image index view), the LCD switches to **Calendar** view, showing a complete month with the first image taken each day as a small thumbnail. Use the arrow keys to navigate between images in the indices and days in the calendar. From the **Calendar** view, it only takes one right-click of the subcommand dial to jump back to the current playback mode.

The background music (BGM) is purely a gimmick, but there's always the possibility you'll find one of the tunes a catchy addition to a slideshow.

Slideshows

This function will automatically advance through the images and movies currently saved on the memory card. By default, slideshows will start with the currently displayed image or movie, advancing sequentially through all the files on the card; only the first three seconds of each movie file will play. Five different melodies can be played as background music, accessed in the **BGM** menu option. In the **SLIDE** option, you can set whether the slideshow plays through only images, only movies, or both.

In the **SETUP** submenu, you can adjust the duration each image will remain displayed during the slideshow (**SLIDE INTERVAL**), and also set the slideshow to play the full length of the movie (**MOVIE INTERVAL**). While the slideshow is playing, the main command dial controls the volume of the music, sound memos, or movie sound recordings.

Movie Playback

As mentioned above, only the first frame of a movie file is displayed on the LCD in playback, with film reels running down the left and right to distinguish it from an image file. Pressing the **INFO** button cycles between an Image-Only playback view and a Simplified view, which shows the

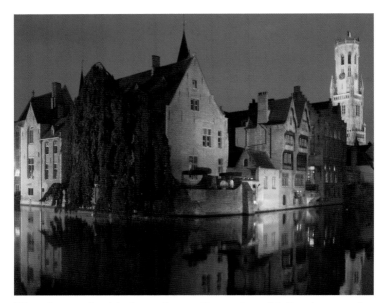

Though you should always be cautious when deleting images, the ability to protect a file gives you the peace of mind that you'll never accidentally lose your most precious shots. 0.4 seconds at f/4.5, ISO 800.

shooting mode, WB setting, resolution (SD or HD), the date and time of capture, the file number, and the sequence number on the card. Additionally, if sound was recorded with the movie, a green 🔊 icon will appear at the top of the LCD.

To enter Movie playback mode, press the ⊛ button while the first frame of the movie is displayed, highlight **MOVIE PLAY**, and press the ⊛ button again. The movie will start playing all the way through, returning to the first-frame view when it reaches the end. Volume can be adjusted at any time by rotating the main command dial. A progress bar will appear beneath the movie display, advancing from left to right as the movie plays; but this will disappear after three seconds unless another button is pressed. A playback time counter remains at the bottom right of the LCD, showing the total movie length on the right and the current play-

back position as it advances on the left. To fast-forward, hold down the right-arrow button; and to rewind quickly, hold down the left-arrow button.

Pressing the ⊛ button while a movie is playing will pause the movie on the current frame. From here, you can rewind or advance frame-by-frame by rotating either command dial or pressing the left-right arrow keys. Pressing the up-arrow key skips to the first frame of the movie, and the down-arrow skips ahead to the final frame. Holding down the right- or left-arrow buttons will play or rewind the movie at normal speed (30 fps).

Television Playback

Images and movies can be played back directly on a television via a tethered connection, using the cables supplied with the camera. All the playback and review options covered thus far are available—perhaps the most useful of which are the Slideshow function and Movie playback.

First, make sure that the 🔳 **VIDEO OUT** submenu is set to the appropriate signal type for your television (NTSC for most countries in North and South America—plus Japan; PAL for everywhere else). Next, plug either the AV cable into the multi-connector, or the HDMI mini-cable into the HDMI input port on the right side of the camera body, and plug the other end of the cable into the input jack on the television. Then turn the TV on, and set it to its Video Input option; turn the camera on, and follow the directions above for normal playback, slideshows, or movie playback.

Erasing and Protecting Files

At any point during any of the playback views, an image can be deleted from the memory card by pressing the 🗑 button to the right of the LCD. By default, a confirmation dialogue will appear, in which you must highlight **YES** and then press the ⊛ button. Whether **YES** or **NO** is the default

highlighted option when the 🗑 button is pressed is determined by the 🎛 Priority Set menu item (page 141). Additionally, activating the 🎛 **Quick Erase** menu item (page 139) will bypass the confirmation dialogue completely, erasing the image as soon as the 🗑 button is pressed. And finally, the **RAW+JPEG ERASE** item of the 🎛 **RECORD/ERASE** submenu determines which file format will be erased when the 🗑 button is pressed—see page 140.

To protect an image against accidental deletion, press the **AEL/AFL** button (notice the blue 🔒 icon to its right) while the image in any playback view. A green 🔒 icon will be displayed in the upper right of the image, which will flash if the 🗑 button is pressed, preventing erasure. Pressing the **AEL/AFL/** 🔒 button a second time will unprotect the image, allowing it to be deleted. This protected status is written into the file itself, and will remain protected when images are transferred to a computer.

Erasing or Protecting Multiple Files

While in any of the six index playback views described above, pressing the ⊛ button will mark the currently highlighted image with a ✔ icon. Using the arrow keys to scroll through the images, you can mark as many files as you like. Then press either the 🗑 button to delete all the currently marked images, or the 🔒 button to protect all of them.

To erase all the images on the card simultaneously, select and confirm the **ALL ERASE** option of the 🗂 **CARD SETUP** menu item (page 107). To unprotect all the images on the card simultaneously, select and confirm the ▶ **RESET PROTECT** menu function (page 112).

Files will remain protected once they are transferred to a computer, ⇨ though this can interfere with your ability to transfer or edit them, depending on the software. 1/125 second at f/8, ISO 200.

In-Camera Image Editing

Besides being a state-of-the-art image capture device, the E-P1 is also a miniature photoshop machine, capable of further processing images that have already been written to the card in over a dozen distinct ways. Pressing the ⊛ button while in any playback view calls up the in-camera edit menu. The available options in this menu depend on the file format of the currently selected image. RAW images must first be processed into JPEGs before further editing can be carried out; and movie files cannot be edited.

RAW Data Edit

Images saved as RAW files can be converted to JPEGs based on the current shooting parameters. This means that any of the image-processing options discussed in pages 62-63 are available—all the Art Filters, Picture modes, WB settings, and contrast, saturation, sharpness, and color adjustments. You cannot, however, change the exposure or focus, meaning that ISO, shutter speed, aperture, and focus mode are all locked when the RAW file is originally captured.

To process a RAW file into a JPEG, simply adjust all the settings and parameters in normal shooting mode as you would for a JPEG capture. Then press the ⊛ button, highlight **RAW DATA EDIT**, press ⊛ again, highlight **YES**, and then press ⊛ one last time. A progress bar will briefly appear on the LCD screen as the JPEG settings are applied to the RAW file, after which the image is displayed as a new JPEG file in the current playback mode.

Image Overlay: The camera can also take either two or three RAW files and merge them into a single image—an after-the-fact version of the Mutiple Exposure function described on page 65. Unlike that function, however, here you can precisely adjust the gain of each image relative to the other(s). To do this, you must first have at least two RAW files saved to the memory card. Then, in any playback mode, press the ⊛ button, highlight **IMAGE OVERLAY**, and press ⊛ again. Select either **2 IMAGES MERGE** or **3 IMAGES MERGE**,

then press ⊛ again. The display will jump to index view, with the currently select image marked with a ✔ icon; from here, scroll to the other image or images you wish to merge to the original file, marking them by pressing the ⊛ button. When the second or third image is marked, the camera instantly begins merging the files, and then displays the **IMAGE OVERLAY** screen shown here.

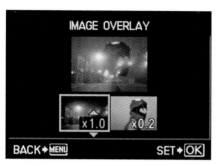

Adjust the gain (or intensity) of each image via the up-down arrow keys or the main control dial, switching between images using the left-right arrow keys or by rotating the subcommand dial. The effects of the relative gain adjustments will be displayed in the main image above—though there will be a slight delay between the adjustments and their preview. Once you've made all your gain adjustments, press the ⊛ button, and a large preview will fill the screen along with a confirmation dialogue. If you're satisfied with the final image, highlight **YES** to render the image, which is then displayed as a new JPEG in the current playback mode.

JPEG Edits

Files saved to the memory card in the JPEG format (either originally or by the in-camera RAW edit described above) can be further adjusted in no fewer than nine additional ways. To open the JPEG Edit menu, press the ⊛ button while displaying a JPEG image in any playback mode.

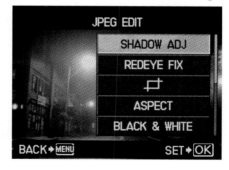

Shadow Adjustment: This function adjusts the tone curve of the image, lifting the shadows in order to lower the contrast and brighten details in areas that appear too dark—similar to the ✎ **AUTO Gradation** setting discussed on page 62. Note that noise may subsequently appear in the brightened shadow areas. To apply the Shadow Adjustment edit, highlight **SHADOW ADJ** at the top of the **JPEG EDIT** menu, and press the ⊛ button. If the previewed image is satisfactory, press ⊛ again to save the new JPEG file, which is then displayed in the current playback mode.

Redeye Fix: If a flash or other light source has caused the redeye effect in any of your subjects, this function attempts to automatically locate the redeye effects and compensate by darkening them to black. To apply a Redeye Fix, highlight **REDEYE FIX** in the **JPEG EDIT** menu, press the ⊛ button, and if the previewed image is satisfactory, press ⊛ again to save the new JPEG file, which is then displayed in the current playback mode.

Crop: The Crop function allows you to trim down the image and save a particular area as a new file, provided the original file is in a 4:3 aspect ratio. The resolution of the image is inevitably decreased, and the original aspect ratio is locked at 4:3. To crop an image, highlight the ⊡ icon in the **JPEG EDIT** menu and press the ⊛ button. The image is overlaid with a green rectangle indicating the borders of the crop, and the areas that will be removed from the outside of the frame are darkened. Rotate either command dial to increase or decrease the size of the crop area, or to switch the orientation between vertical and horizontal. Use the four arrow keys to move the crop rectangle to the desired section of the original image. When the

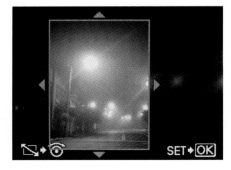

crop is set to your liking, press the (OK) button, and if the previewed image is satisfactory, press (OK) again to save the new JPEG file, which is then displayed in the current playback menu.

Aspect Ratio: This function allows you to change the aspect ratio of the selected image from 4:3 to 3:2, 16:9, or 6:6 (the original image must have been recorded in the 4:3 aspect ratio). Like the Aspect Ratio shooting function described on page 59, this is merely a crop of a 4:3 image, and so resolution is inevitably decreased. To crop the image to a new aspect ratio, highlight **ASPECT** in the **JPEG EDIT** menu, press the (OK) button, highlight the desired aspect ratio, and press (OK) again. The size of the aspect crop is locked, but you can move the 3:2 and 16:9 ratios up or down using the up-down arrow keys, and the 6:6 ratio left or right using the left-right keys. When the desired area is highlighted by the green rectangle, press the (OK) button, and if the preview is satisfactory, press (OK) again to save the new JPEG file, which is the displayed in the current playback view.

Black and White: This function converts a color image into a black-and-white shot. Whichever B&W Filter and Tone (discussed on page 63) are currently set in the Shooting mode will be applied here (much like JPEG settings must first be set before they can be applied to a RAW file in RAW Editing). Once these B&W Filters and Tones are set as desired, highlight **BLACK & WHITE** in the **JPEG EDIT** menu, press (OK) , and if the previewed image is satisfactory, press (OK) again. The new JPEG file will be saved to the memory card, and displayed in the current playback mode.

Sepia: Technically redundant with the **Black and White** edit function described above, this function is a shortcut that applies the Sepia Picture Tone to the currently selected JPEG image. Highlight **SEPIA** in the **JPEG EDIT** menu, press the (OK) button, and if the preview is satisfactory, press (OK) again. The new JPEG file is saved to the memory card, and displayed in the current playback mode.

Saturation: Here the color saturation can be increased or decreased in by five increments in either direction. Highlight **SATURATION** in the **JPEG EDIT** menu, press the ⊛ button, and either rotate

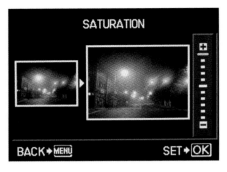

the control dial or press the up-down arrow keys to adjust the saturation. While adjustments are made, both the original image and a preview of the adjustment are shown on the screen; pressing the ⊛ button calls up a full-screen preview that, if satisfactory, can then be saved to the memory card by pressing ⊛ again.

Resize: Here you can resize larger JPEGs down to smaller resolutions—handy for making web-sized images that are easily uploaded to the Internet. Three different resolution sizes are available, depending on the aspect ratio of the original. Simply scroll down to the ⊟ option of the **JPEG EDIT** menu, press the ⊛ button, select the reduced resolution from the new menu that appears, and press ⊛ again. The new JPEG is saved to the memory card, and displayed in the current playback mode.

e-Portrait: As discussed on page 18, this function employs the face detection system to remove blemishes and even out the skin tones of portrait subjects. Scroll to the e-Portrait option of the **JPEG EDIT** menu and press the ⊛ button. If the camera successfully detects a face (or multiple faces), it will apply the e-Portrait mask and prompt you with a confirmation dialogue. If no face is detected, an error message **FACE DETECT ERROR** will appear; in this case, the e-Portrait function is impossible to apply to the image.

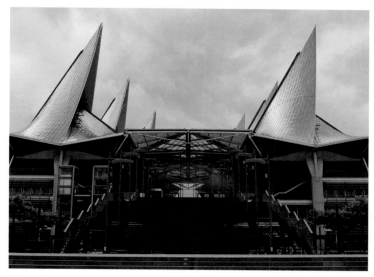

The effects of the Saturation edit function will depend on the Picture Mode of the original image. Vivid images are already saturated, so you won't see much difference; but Muted images respond quite well. 1/640 second at f/8, ISO 200.

🎤 Sound Memo

Besides recording sound as part of a movie file, the E-P1's excellent stereo microphones can also be used to add a sound memo to a recorded image file. This is particularly useful in travel or photojournalistic work, when the context of the image is significant. To record a sound memo, press the ⊛ button while the desired image is displayed in any playback mode, scroll to the 🎤 icon, press ⊛ again, scroll to 🎤 START, and press ⊛ one more time. The camera begins recording sound, and will stop either after 30 seconds have elapsed (as indicated by the timer that appear at the bottom right of the LCD), or when you press the ⊛ button again. The sound memo is saved to the memory card as a .WAV file with the same filename as its associated image.

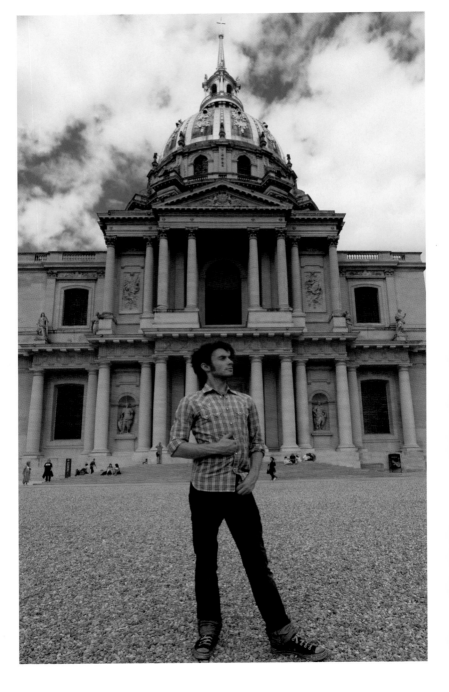

Lens Options

More than just a camera, the E-P1 is part of a complete photographic system. Besides the dedicated Micro Four Thirds lenses, the E-P1 also lets you experiment with a wide range of legacy lenses from a variety of different third-party formats. This is really half the fun of this camera, and the possibilities are practically infinite.

Focal Lengths and Angles of View

Before getting into lens specifics, it's important to understand the relationship between focal lengths and angles of view when lenses are mounted onto the E-P1. When a 50mm lens is attached to a 35mm film camera, it produces a diagonal angle of view of roughly 50 degrees. Take that same 50mm lens and attach it to a Micro Four Thirds camera, which has a sensor about half the size of a 35mm film strip, and it will produce a diagonal angle of view of roughly 25 degrees. The focal length of the lens has not changed at all; but the angle of view is now half as much—it looks like the angle of view from a 100mm lens attached to a 35mm film camera. And because focal lengths are typically understood in 35mm terms, it is common to say that a 50mm lens, when attached to the E-P1, has a "35mm-equivalent" focal length of 100mm. Yes, this is confusing, but don't overthink it. Just know that when you're discussing 35mm-equivalent focal lengths, you need to multiply the focal length of the lens by two.

Composing an ultra-wide angle of view, like this shot taken at 9mm, requires a delicate touch. A slight tilt forward and there would be far too much foreground; a teensy tilt backward and most of the frame would be filled with the sky. 1/640 second at f/8, ISO 200. © Sven Thierie

Deeper Depths of Field

Unfortunately, there's one more aspect of 35mm-equivalence to factor in. As discussed on page 32, depth of field is determined by three factors: focal length, aperture, and focused distance. We've seen how a 50mm lens, when mounted on the E-P1, takes on the angle of view of a 100mm lens on a 35mm body. Now let's say it's a 50mm f/2 lens; if the focused distance is the same for both lenses, the 50mm f/2 lens will create the same depth of field as a 100mm f/4 lens. That is to say, depth of field is doubled along with the focal length.

However, you have to remember that this 35mm-equivalent terminology does not ever affect exposure; exposure is always constant (that's its whole purpose, to offer a standard measurement of light across any photographic system). So even though that 50mm f/2 lens demonstrates the focal length and depth of field characteristics of a 100mm f/4 lens on a 35mm body, it still gathers the same light as an f/2 lens, regardless of what body its attached to. When it comes to exposure, f/2 is f/2 is f/2, no exceptions.

Micro Four Thirds Lenses

At time of writing, there are a relatively small number of Micro Four Thirds lenses—understandable considering the fact that it is a new lens mount. Nevertheless, most of the bases are already covered, with focal lengths ranging from 7mm to 200mm, and the promise of many more lenses on the way. These lenses are designed to maximize the benefits of the shorter flange distance of Micro Four Thirds camera bodies, providing much smaller lenses than those available on D-SLRs. With the exception of the Panasonic 7-14mm f/4 lens, which does not support the **C-AF** focus mode, all the lenses fully support autofocus and autoexposure on any Micro Four Thirds body.

Distortion Correction

Micro Four Thirds lenses are designed with a greater allowance for distortion than normal—though you'll likely never see it. Each lens is programmed to communicate its

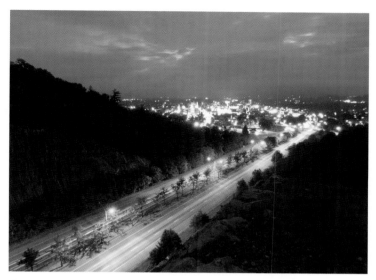

Figuring out 35mm equivalents can be a pain, but it has zero relevance to the important part of photography: capturing beautiful scenes with correct accurate exposures. Don't let yourself get too bogged down in the technical details.

particular degree of distortion to the camera body as soon as it is attached; the camera then corrects the distortion digitally, in both the Live View image shown on the LCD and in JPEGs processed in-camera. RAW files, being unprocessed, still contain the distortion, but compatible RAW processors will likewise digitally correct the image when it is processed later on a computer.

This is a unique byproduct of a Live-View-only camera, because such cameras do not need to project a corrected image through an optical viewfinder. And as a result, lenses can be designed much smaller, and with greater emphasis on sharpness and clarity, because there is much more leeway with regards to distortion. While it is true that there is a slight degradation of quality in this digital correction, it is, for all intents and purposes, imperceptible.

Adapted Lenses

Every lens is designed for a specific lens mount, and every lens mount has a different flange back distance (the distance from the sensor or film plane to the back of the lens). The E-P1's flange back distance is about 20mm—much shorter than most lenses. This means that it can be used with a great number of third-party lenses, because adapters can be used to increase the flange back to the correct distance for any number of specific lens mounts. The flange back distance can always be increased, but never decreased.

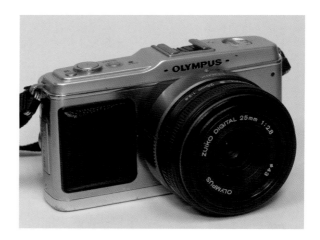

Four Thirds Lenses

Using the Olympus MMF-1 or Panasonic DMW-MA1 adapters (there is no functional difference between them), the E-P1 can support every single Regular Four Thirds lens. This includes **S-AF** autofocus operation as well as the **MF ASSIST** function described on page 53. Note that **C-AF** is not supported. Some lenses will focus more quickly than others, because they have been optimized for CDAF (sometimes called IMAGER AF in various Olympus press releases). Additionally, some lenses are better-suited to the small form factor of the E-P1.

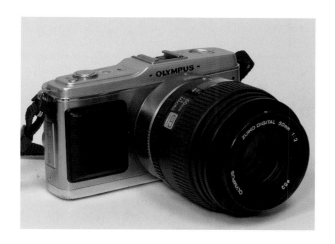

Regular Four Thirds Lenses Optimized for CDAF

Olympus ZD 9-18mm f/4-5.6*
Olympus ZD 14-42mm f/3.5-5.6*
Olympus ZD 14-54mm f/2.8-3.5 II
Panasonic/Leica D 14-50mm f/3.8-5.6
Panasonic/Leica D 14-150mm f/3.5-5.6
Panasonic/Leica D 25mm f/1.4*
Olympus ZD 25mm f/2.8
Olympus ZD 40-150mm f/4-5.6*
Olympus ZD 70-300mm f/4-5.6*

Requires a firmware upgrade

SLR Lenses

Olympus offers the MF-2 adapter for OM-series SLR lenses, Panasonic offers the DMW-MA3R for Leica R lenses, and Novoflex offers a wide variety of other adapters for pretty much any lens mount you can think of. These adapters are simple mechanical devices that only add the necessary flange back distance to allow proper focusing and mounting; they do not offer any electronic coupling, so autofocus

and Shutter-Priority shooting mode are both disabled. If the adapted lens lacks an external aperture dial, it will only be able to be used at its maximum, widest aperture (lowest f/stop).

If the lens does have an external aperture dial, then Aperture-Priority shooting mode will be available, though the current f/stop will not be displayed on the LCD screen (you'll have to look on the lens itself). The sensor will still be able to take an exposure reading, and generate shutter speeds accordingly. However, these will not always be exactly accurate; some trial and error is necessary here. For many lenses, you will find that an exposure compensation is necessary as a default.

Rangefinder and C-Mount Lenses

These lenses can be made extremely compact, and fit the small form of the E-P1 very well. The advice given above for SLR lenses applies here—Shutter-Priority and autofocus are disabled, and exposure compensation may be necessary. Additionally, it is important to note that the wider the lens, the less well it will perform on the E-P1. This is because the digital sensor is designed for light to strike it at as perpendicular an angle as possible (a concept called telecentricity). Wide film lenses, of focal lengths generally lower than 35mm, strike the sensor at an oblique angle, which results in smearing and a degradation of image quality—particularly at the corners and edges of the frame. These lens designs can also heavily vignette at wider apertures. Whether this is a deal-breaker for you in terms of image quality is a matter of personal taste, but it is an important consideration when choosing a lens.

Note: The 🄶 **SHADING COMP**. feature, discussed on page 138, will attempt to automatically correct any vignetting that the camera detects. This can be very useful when using adapted lenses.

Flash Photography

Though the E-P1 lacks a built-in flash, it does offer a number of advanced flash options through the use of a dedicated external flash unit. To mount a flash unit, first remove the hot shoe cover, and insert the unit with the flash head facing forward. Then turn the ring around the base of the flash unit clockwise until it is tightly secured against the camera body. When a dedicated flash is attached, the full range of flash options will be enabled on the camera.

The Inverse Square Law

The intensity of the light emitted from a flash unit is inversely proportional to the square of the distance it has to travel. The farther the light travels, the weaker it will be when it reaches the subject; and the more powerful the light is when it begins its travel, the farther it can reach. This fundamental formula of flash illumination is called the Inverse Square Law:

$$\text{Light Intensity} = 1 / \text{Distance}^2$$

It's much easier to understand in practice: If the distance between the subject and the flash unit is doubled, the light needs to be four times as powerful in order to maintain a constant exposure. If the distance is tripled, the flash needs to be nine times as powerful. Quadrupled? Sixteen times as powerful! You get the idea.

Fill flash is a counterintuitive technique—you have to remember that your human eye is capable of resolving high-contrast scenes much better than the imaging sensor. Here, the strong backlight and white wedding dress inclined the metering system to underexpose the shot. A touch of fill flash helped lighten up the bride's face without overexposing other parts of the scene.

97

Guide Numbers

Every flash unit has a specific guide number that is used to describe how much light it is capable of producing at any given ISO. As a formula, the guide number (GN) equals the distance times the aperture (GN = distance x f/stop). Guide numbers are expressed using either feet or meters, so make sure to check which system of measurement is being used. Because the E-P1 calculates flash exposure automatically, you won't usually need to work out the math; the important thing is to remember that the higher the guide number, the more powerful the flash unit and the farther its light can reach.

Bounce Flash

By firing the flash at a nearby wall or ceiling instead of directly at your subject, you can diffuse the artificial light as it is reflected off of that surface and onto the subject. Shadows will be less harsh, and the scene will appear more natural. Of course, the flash unit must be free to move off of the lens axis, either by a swivel feature or an off-camera cord. The flash will take on the color of the surface off of which it is bounced, so white walls and ceiling are usually the best options. And the Inverse Square Law still applies—the camera-to-subject distance will be increased, so the power of the flash must be increased accordingly.

The X-SYNC and SLOW LIMIT values will automatically adjust to make sure the former is always faster than or equal to the latter.

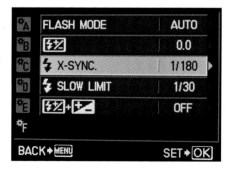

Flash Sync Speeds

In order to evenly expose a subject, the flash must fire when the shutter is fully open and the entire sensor is exposed. The top shutter speed at which this can occur is called the

Bounce flash is a blessing, but you'll usually have to dial in a positive flash exposure compensation in order to get the extra reach (as per the Inverse Square Law). 1/320 second at f/8, ISO 200.

⚡ X-Sync Speed, and is 1/180 second on the E-P1. The lowest possible shutter speed at which this can occur is called the ⚡ Slow Limit, and is 1/30 second on the E-P1. Both of these values are set in the 🎛 ⚡ **CUSTOM** menu shown here. The difference between these values is the window of possible shutter speeds from which the camera will choose when determining flash exposure. Naturally, the Slow Limit must always be below the X-Sync Speed, and the X-Sync Speed must always be above the Slow Limit.

Flash Control Modes

Flash Control modes are set on the flash unit itself, unlike the flash exposure modes which are set in the camera. Which Flash Control modes are available depends on the flash unit in use.

TTL AUTO: A rapid series of pre-flashes are fired just before the shutter is released, which supply the camera with exposure and distance information. The camera then adjusts the flash output to correspond to current ISO, shutter speed, and aperture value settings.

FP TTL AUTO: The same series of preflashes described above are used to calculate exposure. However, shutter speeds greater than 1/180 second are available by firing a second series of flash bursts as the shutter is traveling across the sensor plane. This consumes more electricity and decreases the power of the flash, which is understandable since it is meant to be used in daylight with high shutter speeds to provide fill flash. It is not recommended for normal flash shooting, where the flash unit provides the majority of subject illumination.

AUTO: The flash unit uses a built-in sensor to calculate exposure based on the current ISO and aperture values. No preflashes are fired. This flash control mode is not recommended, as it is not as accurate as the TTL AUTO mode.

MANUAL: The flash fires without any automated calculation of exposure whatsoever. You have to determine correct flash exposure based on ISO, subject distance, and aperture value, and then input the corresponding guide number into the flash unit. Naturally, this requires a mastery of the intricacies of flash photography; it is most useful in difficult lighting situations where the flash must be balanced against the intensity of ambient light.

FP MANUAL: Just like Manual Flash Control mode, except higher shutter speeds can be used by firing multiple flash bursts as the shutter is traveling across the sensor (like in FP TTL AUTO mode).

Flash with Shooting Modes

Flash is controlled differently depending on which shooting mode is being used. In Program and Aperture-Priority shooting modes, the camera will automatically select a shutter speed from the available sync window as described above. However, Aperture-Priority does give more control over the effects of the flash, because the f/stop is a deciding factor in the final output of the flash. The wider the aperture, the farther the flash will be able to reach; narrower apertures will restrict the flash's power, thus requiring lower shutter speeds. Shutter-Priority shooting mode, obviously, allows

you specify the precise shutter speed, which will be limited by the X-Sync speed unless FP TTL AUTO flash control mode is used. And Manual shooting mode gives the maximum amount of control over all available settings and functions.

Flash Exposure Modes

The E-P1 offers six different flash exposure modes that control the various effects that flash units will have when they are attached to the camera. They are accessed in either the Live Control Menu or the Super Control Panel.

AUTO Flash
All flash settings are fully automated, and the flash will only fire if the camera detects insufficient lighting for a non-flash exposure.

⚡ Fill Flash
The flash unit will fire regardless of the current lighting conditions. Because the color temperature of flash is very close to sunlight (see page 49), this means the flash can be used in broad daylight in order to fill in the shadows on a subject's face, or compensate for strong backlighting in contrasty conditions.

Note: Since bright daylight usually requires shutter speeds faster than the top X-Sync speed of 1/180 second, this flash exposure mode is best used with the FP-TTL AUTO flash control mode.

👁 Red-Eye Reduction
When the flash fires directly into the eyes of a subject, it can reflect off of their retinas and create the unsettling and undesirable red-eye effect. This mode fires a series of pre-flashes that cause the pupils of the subject's eyes to constrict, so that when the final flash fires there is less likelihood that the red-eye effect will occur. The preflashes can, however, be quite distracting at times; if discretion is important, you can always correct the red-eye effect using the JPEG Edit function described on page 84.

Slow-sync flash, though sometimes unpredictable, is unparalleled in its ability to infuse an image with a dynamic sense of action. 5 seconds at f/5.6, ISO 200.

Slow-Sync Options

In other flash exposure modes, the camera uses the fastest possible X-sync speed to ensure sharpness and eliminate camera shake. However, the flash can be set to fire for only a fraction of the total shutter speed, which allows ambient light far beyond the reach of the flash to contribute to the exposure.

⚡SLOW: This will fire the flash at the very beginning of the exposure, allowing ambient light to overlap the initial flash as the shutter travels across the sensor.

👁SLOW: This combines the above-described **⚡SLOW** flash mode with the red-eye reduction function, and is designed for nighttime portraits.

⚡SLOW2: In this mode, the flash fires twice: once at the very beginning of the exposure, and again at the very end. Therefore, if there is subject motion, the subject will appear sharp in two locations in the scene, connected by a trail of motion blur.

Flash Exposure Compensation ⚡Z

If the subject is over- or underexposed when using flash, you can manually compensate by increasing or decreasing the flash intensity by +/-3EV. Control over ⚡Z Flash Exposure Compensation is accessed either in the Super Control Panel, or by mapping it to one of the control dials in the 📷B DIAL FUNCTION submenu.

By activating the ⚡ ⚡Z+Z menu option, this feature can be used in conjunction with the normal Z Exposure Compensation feature to augment this range: for example, if by dialing in +3 ⚡Z and +3 Z , the total exposure compensation will be +6EV. For most purposes, however, you will not need this extra range, and keeping track of both compensation values can be quite a headache; therefore I recommend keeping ⚡Z+Z deactivated.

Available Flash Units

FL-14
This retro-styled flash unit was designed specifically for the E-P1, and keeps its form as compact as possible. It has a guide number of 14 (hence the name), and has a fixed coverage of 14mm (meaning it does not zoom in our out depending on the focal length in use). It does not offer FP-TTL AUTO or FP MANAUL flash control modes, and requires two AAA-type batteries to provide between 80 or 130 flashes.

Olympus FL-14 Flash

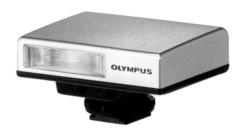

Though this flash unit is appreciably compact, its lack of bounce capability, and its limited coverage and power significantly curtail its usefulness. If you plan on using flash for anything other than fill flash and casual indoor snapshots, I recommend putting your money toward the FL-36 flash unit.

FL-36

This flash unit is as big as the E-P1 itself, but offers considerably more capability and functionality than the FL-14. It has a guide number of 36 and is powered by two AA batteries. For bounce flash capabilities, the flash head can be swiveled 270 degrees on its horizontal axis, and 90 degrees on its vertical axis. The flash will also automatically zoom in or out depending on the focal length of the lens in use, and its built-in wide-angle dif-

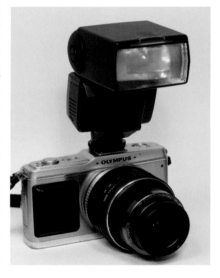

fuser allows coverage for lenses as wide as 10mm. It also has a dedicated flash intensity dial that, when used in MANUAL flash control mode, functions just like flash exposure compensation.

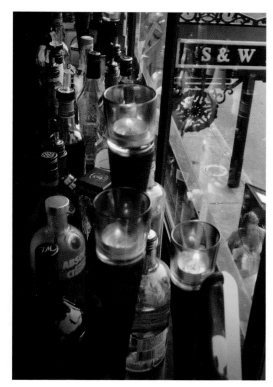

Note that although the FL-36 and FL-50 flash units contain AF-Assist lamps designed to aid the autofocus system in low light, this feature is deactivated when these units are mounted to the E-P1.

This flash comes in two versions: FL-36 and FL-36R. The "R" model can be controlled wirelessly by certain Four Thirds D-SLRs; but the E-P1 does not support wireless flash, so the distinction here is irrelevant.

FL-50

This flash unit carries all the features of the FL-36 flash unit described above, but provides even more flash power with a guide number of 50, powered by four AA batteries. While this added power can come in handy, the FL-50 is extremely large for the E-P1's compact body, making the camera top-heavy and difficult to handle. Like the FL-36, there is an "R" model that supports wireless flash, even though the E-P1 cannot make use of that capability.

The Menu System and Recommended Custom Settings

As mentioned many times elsewhere, the E-P1 has a complex menu system that can be a real hassle to navigate. Nevertheless, there are some remarkable features buried here that will seriously help your photography; besides, many of these settings can be adjusted once and never bothered with again. It's well worth your time to read through this chapter thoroughly and familiarize yourself with the intricacies of customization available, so that when you see a worthy shot, you'll be ready to capture it that very instant.

◖ Shooting Menu 1

The important functions here are the **CARD SETUP** and **CUSTOM RESET** menu options. Everything else can be set from the Super Control Panel, with the exception of the **CUSTOM** Picture Mode (described on page 63).

◖ CARD SETUP

This has two options—**ALL ERASE** and **FORMAT**. **ALL ERASE** will delete any and all image and movie files found in the DCIM folder of the card. Any other file types, or image and movie files that are stored outside that folder, will not be deleted. The only way to completely wipe the card of absolutely everything and restore it to its original defaults is to select and activate **FORMAT**, as described in the introduction.

ALL ERASE	FORMAT

↶ *Even if a card is blank, it's always a good idea to format it before recording new images. This can speed up card-write times and free up extra memory, and improve overall responsiveness.*

▣ CUSTOM RESET

Any changes made while in the **P**, **A, S**, or **M** shooting modes will be saved when the power is turned off. By activating the **RESET** option, all of those changes will revert back to their factory defaults except the following:

Settings NOT Affected by Custom Resets

MULTIPLE EXPOSURE	⊕ (Date & Time)	●⊞ (Language)
🔲 (LCD Brightness & Contrast)	✿ MENU DISPLAY	FIRMWARE
MY MODE SETUP	BUTTON TIMER	VIDEO OUT
USB MODE	☻ FACE DETECT	ALL WB✝
FILE NAME	PRIORITY SET	dpi SETTING
EDIT FILENAME	PIXEL MAPPING	HDMI

In addition to restoring defaults, this function allows you to create and save two different profiles, each with their own different combinations of settings, customized for their own specific purposes. Simply adjust all the settings (except those listed above) to your liking, go to **RESET1**, press the right-arrow button, and select SET. Now all those settings are saved to the **RESET1** profile. To return to that profile after other settings have been changed, go to **RESET1**, press the ⊛ button, and select **YES**. Follow the same procedures to create a second profile under **RESET2**.

▣ PICTURE MODE

With the exception of the **CUSTOM** mode, all these Picture Modes (page 62), along with their corresponding Contrast, Saturation, and Sharpness adjustments, are much easier to access via the Super Control Panel. See page 63 for direction on setting the **CUSTOM** Picture Mode.

⚡ VIVID	CONTRAST
⚡ NATURAL	SATURATION
⚡ MUTED	SHARPNESS
⚡ PORTRAIT	
MONOTONE	CONTRAST
	SHARPNESS
	B&W FILTER N., Ye., Or., R., & G.
	PICT. TONE N., S., B., P., & G.
CUSTOM (screen 2)	PICTURE MODE
	CONTRAST
	SHARPNESS
	SATURATION
	GRADATION

⚓ GRADATION

As described on page 62, *✐* **GRADATION** controls certain aspects of the exposure, and is best accessed via the Super Control Panel.

AUTO	NORMAL	HIGH KEY	LOW KEY

⚓ ◀▦ (Resolution)

As described on page 60, ◀▦ determines the resolution of the current still image or movie, and is best accessed in the Live Control Menu or Shooting Control Panel.

STILL PICTURE	MOVIE

⚓ IMAGE ASPECT

As described on page 59, the Image Aspect can be set to one of four different possibilities, though only the 4:3 option gives full resolution.

4:3	3:2	6:6	16:9

▣₂ Shooting Menu 2

The only important functions here are **MOVIE AE MODE**, **MOVIE + STILL**, and **MULTIPLE EXPOSURE**. ▣ↁ and **IMAGE STABILIZER** are available in the Live Control Menu and Super Control Panel.

▣₂ MOVIE AE MODE
As described on page 70, this function determines which shooting mode is used while you record a movie.

P	A	ART 1, 2, 3, 4, 5, & 6

▣₂ MOVIE+STILL
As mentioned on page 69, by activating this function, a full-resolution still image will be captured at the end of every movie.

OFF	ON

▣₂ ▣ↁ (Drive Mode)
This menu is merely a reiteration of the Drive Mode adjustments available in the Live Control Menu and Super Control Panel (see page 51).

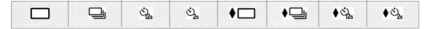

▣₂ IMAGE STABILIZER
As described on page 51, this function determines which of the three IS modes is in use, or which focal length is set for a non-Micro or Regular Four Thirds lens. It is much more easily accessed via the Live Control Menu or Super Control Panel.

OFF	I.S. 1	I.S. 2	I.S. 3

📷₂ **MULTIPLE EXPOSURE**

This feature allows you overlap multiple exposures, as described in detail on page 65.

FRAME	OFF	2F (2 Frames)
AUTO GAIN	OFF	ON
OVERLAY	OFF	ON

▶ **Playback Menu**

All of these playback functions are important, as they can only be accessed in this menu.

▶ 🖭 **Slideshow**

As described on page 77, here you can set the background music for slideshows to one of five options, or deactivate it entirely. You can also select the length of time each image will remain displayed on the LCD, and whether movie files will play in full, or only as snippets.

START	
BGM	MELANCHOLY
	NOSTALGIC
	LOVE
	JOY
	COOL
	OFF
SLIDE	ALL
	STILL PICTURE
	MOVIE

▶ ⌔ (Image Rotation)

When this is activated, the camera will automatically rotate images taken in vertical portrait orientations so that they appear upright in the LCD. Though this may seem helpful, it comes at the cost of a reduced image (though it can still be magnified for close inspection). Additionally, the electronic gyroscope can get confused if the shot was taken at an odd angle, automatically rotating it away from you at every turn. Since the camera is so small, it's much easier to deactivate this setting and just turn the camera itself in order to evaluate vertical shots.

YES	NO

▶ EDIT

This section accesses all the RAW DATA and JPEG EDIT functions described on pages 82-87.

SEL. IMAGE	RAW DATA EDIT	
	JPEG EDIT	SHADOW ADJ / REDEYE FIX / IS☒ / ASPECT / BLACK&WHITE / SEPIA / SATURATION / IS☒ / e-PORTRAIT
	🎤	NO / 🎤 START/YES
IMAGE OVERLAY	2 IMAGES MERGE / 3 IMAGES MERGE	

▶ 凸 (DPOF)

This is where you specify which frames you want to print directly from the camera, and how many of each (see page 148).

凸	凸

▶ RESET PROTECT

As mentioned on page 80, this function will cancel the ⌸ status of any image or movie files on the memory card.

YES	NO

ⓕ Setup Menu

This menu contains some fundamentals that will be set when the camera is first activated, and will remain untouched most of the time.

ⓕ ⊕ (Time and Date)
As discussed in the introduction on page 17, this is where you set the time and date, as well as the format in which that information appears.

Day	Month	Year	TIME	[format]

ⓕ ●▤ (Language)
Here you can change the language from its factory default of English to one of thirty-two other languages.

ⓕ ▭ (LCD Adjustment)
This function allows you to fine-tune the brightness and color temperature of the LCD. Brightness adjustments are useful if you find the LCD difficult to view in harsh lighting conditions. However, I caution against adjusting the color temperature unless you are using some measure of control, as it will skew the representation of colors in the Live View image (though the colors of the image itself will be recorded normally).

🌡	+/-7
▭	+/-7

ⓕ REC VIEW
This determines how long an image will be displayed immediately after it is shot—as mentioned on page 21. If AUTO ▶ is selected, the camera will automatically switch to Playback mode after each and every shot (which gets very annoying).

1SEC – 20SEC	AUTO ▶	OFF

✿ MENU DISPLAY

This setting definitely needs to be turned on, as it activates the nine Custom Menus described below, providing access to some of the key features of the camera.

OFF	ON

ꙮ FIRMWARE

This setting simply displays the current firmware version of both the lens and the body; it is not used for updating the firmware—that requires the use of the Olympus Master or Studio software (see page 146).

✿ Custom Settings Menus

These menus get under the hood of the E-P1 to allow a remarkable, and sometimes intimidating, degree of customization and control. Feel free to disregard my recommendations if you feel differently—I'm only trying to help make sense of this cavernous system of menus and submenus.

Note that some menus have two screens, in which cases the second screen is accessed by scrolling vertically through the first six menu options. Additionally, some menus have several submenus that operate along a horizontal axis. Keep track of which menu you are in at any given time—it will help you become familiar with the camera so that quickly accessing certain settings become second nature.

⚞ AF/MF

The most important functions in this menu are **RESET LENS**, **BULB FOCUSING**, and **MF ASSIST**. Note that **MF ASSIST** is hidden on a second screen that can only be accessed by scrolling past the first six menus.

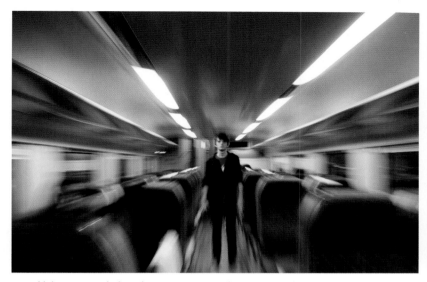

Using a steady hand, you can zoom in or out during a longer shutter speed to create this zoom-burst effect. The results can be unpredictable, but its a fun technique to play around with. 0.5 seconds at f/8, ISO 200.

AF MODE

Accessible via the dedicated button, Live Control Menu, or Super Control Panel—see page 52.

STILL PICTURE	S-AF / C-AF / MF / S-AF+MF
MOVIE	S-AF / C-AF / MF / S-AF+MF

AF AREA

Accessible via the Live Control Menu or Super Control Panel—see page 54.

[∷]	[·]

⬛ [···] SETUP

This frivolous feature sets the order in which the various AF areas will be cycled through as the main command dial is rotated. I recommend leaving it on its default of **SPIRAL**.

OFF	LOOP	SPIRAL

⬛ RESET LENS

By default, the camera will return the lens to an infinity focus position each time the camera is turned off; by setting this feature to OFF, the lens will remain at its current focus position. Unless you are doing some tripod work at a constant focus distance and frequently turning the camera on and off to conserve battery power, I recommend leaving this ON, as it prevents the front lens element from being exposed during storage.

OFF	ON

⬛ BULB FOCUSING

When using the **BULB** mode described on page 34, this feature, when activated, will allow the lens to be refocused while the shutter remains open. It is best left at its default, unless you find the camera is being accidentally defocused during **BULB** shooting.

OFF	ON

⬛ FOCUS RING

The focus barrels of Micro Four Thirds lenses are not directly coupled to the focus motors, instead using an electronic fly-by-wire system that can be customized to rotate in either direction. The icons indicate the direction of lens rotation as it focuses toward infinity, from the point of view of the shooter (behind the camera). Pick whichever direction feels comfortable and natural, and you'll likely never need to set this function again.

↺	↻

▣ (Screen 2) MF ASSIST

As discussed on page 53, I highly recommend setting this innovative feature to **ON**, as it allows you to quickly confirm precise focus when using **MF** focus mode. However, if you find you are accidentally rotating the focus barrel and the zoom view is skewing the Live View preview, by all means turn it **OFF**.

OFF	ON

▣ BUTTON/DIAL

This is one of the most important custom menus, as it determines the various functions assigned to each of the E-P1's numerous manual controls.

▣ BUTTON FUNCTION

When the submenu for each shooting mode (and **MENU**) is accessed, this diagram appears, indicating which function will be assigned to which control dial. I do not recommend mapping ☑ Exposure Compensation to either dial in any shooting mode, as you can easily adjust it by simply holding down the ☑ button itself; mapping it to a dial only increases the likelihood of accidental compensation, which can skew your exposure. Likewise, I do not recommend doubling up the functions so that both dials adjust the same setting. The main command dial is simply too easy to accidentally move while the camera is being held; therefore, I recommend mapping it—in **P**, **A**, and **S** modes—to the innocuous ☑ Flash Exposure Compensation function. This way the main command dial can be accidentally adjusted without affecting the exposure (provided no flash unit is attached—if it is, you must use caution).

As for **M** shooting mode and **MENU**, the decision is entirely a matter of personal taste; set to whatever feels natural, and you'll likely never need to return here again.

P	Ps (Program Shift) / (Exposure Compensation) / (Flash Exposure Compensation)
A	FNo. (Aperture) / (Exposure Compensation) / (Flash Exposure Compensation)
S	SHUTTER (Shutter Speed) / (Exposure Compensation) / (Flash Exposure Compensation)
M	SHUTTER (Shutter Speed) / FNo. (Aperture)
MENU	◄► / ▲▼ VALUE

DIAL DIRECTION

Another frivolous function; unless you feel the default setting for which direction dials positive values when the main command dial is rotated is counterintuitive, leave this menu alone. If you find you are constantly increasing values when you mean to decrease them, and vice versa, adjust this function to the opposite setting.

AEL/AFL

This is another critical feature that can help eliminate shutter lag and increase the camera's responsiveness. First, I recommend setting S-AF to Mode 2, as this allows you to perform AEL (Autoexposure Lock) separately from AFL (Autofocus Lock), giving the maximum amount of flexibility when using the autofocus system.

S-AF AEL/AFL

mode 1

HALF WAY : AEL/S-AF
FULLY : EXPOSURE
[AEL/AFL] : AEL

BACK→MENU SET→OK

S-AF	Mode 1	Half: AEL/S-AF	Fully: EXPOSURE	[AEL/AFL] : AEL
	Mode 2	Half: S-AF	Fully: AEL/ EXPOSURE	[AEL/AFL] : AEL
	Mode 3	Half: AEL	Fully: EXPOSURE	[AEL/AFL] : S-AF

Next, I recommend setting the C-AF function to Mode 2, as this will allow you to take a separate AEL reading before beginning Continuous AF.

C-AF	Mode 1	Half: AEL/AF Start	Fully: AFL/EXP	[AEL/AFL] : AEL
	Mode 2	Half: AF START	Fully: AEL/AF/EXP	[AEL/AFL] : AEL
	Mode 3	Half: AEL	Fully: AFL/EXPOSURE	[AEL/AFL] : AF START
	Mode 4	Half: no effect	Fully: AEL/AFL/EXP	[AEL/AFL] : AF START

Finally, I recommend setting the MF function to Mode 3, as it allows you to manually focus while still having S-AF autofocus as a backup in the [AEL/AFL] button.

MF	Mode 1	Half: AEL	Fully: EXPOSURE	[AEL/AFL] : AEL
	Mode 2	Half: no effect	Fully: AEL/EXPOSURE	[AEL/AFL] : AEL
	Mode 3	Half: AEL	Fully: EXPOSURE	[AEL/AFL] : S-AF

⊞ AEL/AFL MEMO

This setting determines whether an autoexposure lock will be maintained with a single press of the 🔲 button, or if that button will need to be held down to hold the exposure. To prevent accidental AEL, I recommend setting this to **OFF**.

OFF	ON

⊞ Fn FUNCTION

This advanced customization feature allows you to map one of nine unique functions to the Fn button located on the camera back. It is an invaluable tool, and one which you will likely adjust depending on the type of shooting you're doing at any given moment. So take note of where it is in the menus! First off, whatever you do, do not waste this valuable feature by setting it to **MF**, **RAW** ◀︎:· , ⦿TEST, or **BACKLIT LCD**; all these functions can be accessed more easily elsewhere (with the exception of ⦿TEST, which is irredeemably useless and you simply needn't bother with it). And whatever you do, don't set it to **OFF**! Take the time to read through the following descriptions of available and useful functions, and determine which one you're likely to want to access on the fly.

OFF	Fn FACE DETECT	PREVIEW	🖵	[••] HOME
MF	RAW ◀︎:·	TEST PICTURE	MY MODE	BACKLIT LCD

☺ **Fn FACE DETECT:** Automatically activates Face Detection, sets the metering mode to 🔲 ESP, and sets the ◀︎:· Gradation to **AUTO**. I suppose this is useful if you're shooting landscapes and suddenly a face sneaks up on you that you have to capture in an almost fully-automated exposure, but in any other case, I don't recommend this setting, as it can be accessed in the Live Control Menu and Super Control Panel with minimal effort.

Gritty urban environments are ideally suited for the Grainy Film Art Filter—particularly on sunny, contrasty days with lots of long shadows. 1/400 second at f/6.3, ISO 200.

PREVIEW: Will close down the aperture to its current setting (it usually remains wider in order to allow the brightest possible image on the LCD). This allows you to inspect the depth of field that will be present in the image at any given aperture. However, without the ability to zoom into the LCD screen, this function is not usually very beneficial, unless you're doing very close macro work in which out-of-focus areas are easy to distinguish.

One-Touch WB: Discussed at length on page 50, this is an invaluable tool in certain situations, and the **Fn** button is the only way to access it. So it's really quite simple: if you need to set a One-Touch White Balance specific to a certain light source, your only option is to set the **Fn** button to this function.

[••] **Home AF Area:** When selected, pressing the **Fn** button will override any single AF area that you've previously set (see page 54) and switch to the **[::::]** AF area mode, using all eleven focus targets. If **[::::]** is already selected, then the **Fn** button will have no effect. However, you can also adjust this function to make the **Fn** button revert to a single, pre-saved AF area by assigning a **Home AF** area. To do this, scroll to the **[•]** AF Area icon in either the Live Control Menu or Super Control Panel to display all eleven AF areas. Rotate the command dials or use the arrow buttons to select one AF area, and simultaneously press the **⊞** button while holding down the **Fn** button. A **HP** icon will appear at the bottom left of the LCD to indicate that this is the **Home AF** area. Obviously, this feature is complex and can indeed be useful in certain situations where you need to switch between all eleven AF areas and one in particular; if that is the case by all means invest the time necessary to set up the **Home AF** area and map it to the **Fn** button. But for most situations, this will be a superfluous function.

MY **MY MODE:** This will map the **Fn** button to the currently selected **MY MODE** option (described below). This can be quite useful in rapidly switching between a wide variety of settings, but it takes some preparation to be made truly useful. First, follow the directions below on how to configure the **MY MODE SETUP** menu option. Once one of those two **MY MODES** is set, it will be recalled with a press of the **Fn** button—however, this will only be useful if other settings have been changed since you initially configured the **MY MODE SETUP**. So only map the **Fn** button the **MY** if you've already completely re-configured the camera and need to quickly revert it back to a customized and pre-saved profile.

B **◄** **FUNCTION**
This feature acts just like the **Fn** **FUNCTION** feature described above, but maps a particular function to the **◄** button instead. By default, the **◄** button serves as a dedicated AF Mode button (as marked— **AF** . However, that function is also accessible via the Live Control Menu and Super Control Panel. Therefore, I recommend setting this

feature to **I▢I BACKLIT LCD**. This gives you the ability to turn the LCD screen on and off without powering down the entire camera, which greatly increases the length of battery charge; it also is very useful when using an optical viewfinder attached to the hot shoe, as it eliminates the distracting ambient light from the LCD, allowing you to see a clearer image through the viewfinder.

AF—AF MODE	▣ — METERING	⚡ — FLASH MODE	I▢I— BACKLIT LCD	IS— IMAGE STABILIZER

▣ (Screen 2) MY MODE SETUP

This menu is functionally similar to the **CUSTOM RESET 1&2** options described on page 108, meaning that it allows you to save a variety of current settings and adjustments to two separate profiles (**MY MODE 1** and **MY MODE 2**), which can then be recalled at any time. They differ from the CUSTOM RESET functions in that they offer fewer settings able to be saved, but can be quickly activated by pressing the **Fn** button (provided that button is mapped to the ▣ option).

The settings that can be saved to either **MY MODE** are given below:

▣	IS Mode	▣▣	Flash Mode
Picture Mode	Gradation	Still Picture ◀▦	Aspect Ratio
▣	Autoexposure Bracketing	White Balance Bracketing	Flash Bracketing
ISO Bracketing	Still Picture AF Mode	AF Area	S-AF Release Priority
C-AF Release Priority	Live View Boost	EV Step	Metering
ISO	ISO Step	Anti-Shock [♦]	⚡ X-Sync
⚡ Slow Limit	Noise Reduction	Noise Filter	White Balance
▣ WB Compensation	Color Space	Shading Compensation	Exposure Shift

To save a certain combination of these settings to a **MY MODE**, scroll to either **MY MODE 1** or **MY MODE 2**, press the right-arrow button, and select **SET**. All the current settings will now be saved to that **MY MODE**. To recall those settings at any time, scroll back to that particular **MY MODE** and press the ⊛ button, and then select **YES**.

⬛ (Screen 2) BUTTON TIMER

A number of functions on the E-P1 are carried out by simultaneously pressing a button and rotating a dial. For instance, by default, to adjust the ⬛ Exposure Compensation, you must press the ⬛ button first, and you then have 8 seconds to rotate the main command dial to make your adjustment. This submenu determines the lengths of time the camera will wait between the press of the button and the rotation of the dial. I strongly recommend setting this menu option to **OFF**, which will require you to hold down the ⬛ button while you rotate the dial. This prevents accidental adjustments and improves the response time of the camera. Note that **HOLD** is counterintuitive here: it does not mean you must hold down the button while rotating the dial (that is the **OFF** setting); **HOLD** means the camera will "hold" the button's function open for an unlimited amount of time, allowing you to rotate the dial at your leisure—and greatly increasing the chance of accidentally changing it by forgetting to press the button a second time.

OFF	**3SEC**	**5SEC**	**8SEC**	**HOLD**

⬛ (Screen 2) ⬛⇌⬛

Another strange feature, this submenu allows you to switch the functions assigned to the ⬛⇌⬛ and ⬛ buttons. As another matter of personal taste, if you find that one button is easier to access on-the-fly than another, by all means activate this function as you see fit.

OFF	**ON**

124

🔲 (Screen 2) ⬚ FUNCTION

Here you can deactivate all four of the directional arrow keys and their associated dedicated functions. Though this seems like a waste of valuable controls, it may be necessary if you find that you are frequently making changes by accident. For instance, when using gloves, this can prevent unintended adjustments to important settings. Additionally, you can map the ⬚ buttons to determine the current AF Area on the fly, but that is a far more cumbersome option than simple AF Lock (page 20), and I do not recommend it.

OFF	ON	[●●]

🔲 RELEASE / 🗇

By default, fully pressing the shutter-release button will fire the shutter only if autofocus has been confirmed. By activating these two functions (**RLS PRIORITY S** for S-AF mode, and **RLS PRIORITY C** for C-AF mode), the shutter will fire whenever the shutter release is fully pressed, regardless of whether or not autofocus has been achieved. I strongly recommend activating both of these functions, as there is nothing more frustrating that pressing the shutter release and having nothing happen. You can always confirm autofocus by checking for the green dot at the upper right of the LCD yourself, and a slightly out-of-focus shot is often better than no shot at all!

RLS PRIORITY S	OFF /
RLS PRIORITY C	ON

🔲 DISP / ●)) / PC

Here you'll find a number of settings relevant to playback, be it on the camera's LCD, a TV, or a computer.

You can always tell whether the camera is asleep or turned off by the green ring around the power button. If it's lighted up while the LCD is blank, the camera is just asleep and will be ready to shoot an instant after you tap the shutter button. 1/125 second at f/9, ISO 200.

⚏ HDMI

This setting must match up with the **VIDEO INPUT** specified for your TV (when it is used for TV Playback—see page 79). 1080i is the default, and highest resolution available; when at all possible, leave this setting in place. Usually, the TV will automatically select 720p if it has to. 480p is for Standard Definition playback on an NTSC device, and 576p is Standard Definition on a PAL device (see below).

1080i	720p	480p/576p

⚏ VIDEO OUT

As discussed on page 79, this setting must match up to the TV being used for playback.

NTSC	PAL

⚏ ■))) (AF Confirmation)

This submenu determines whether or not the autofocus confirmation will sound an audible chirp once autofocus is achieved. It is a matter of personal taste, but if discretion is important, I recommend setting this feature to **OFF**. The green dot will still alight in the upper-right of the LCD screen to let you know that autofocus is locked—those around you need not be aware of the fact.

OFF	ON

⚏ SLEEP

Here you can set how long the camera will wait without any controls being pressed before it automatically deactivates. It will not turn off completely—the startup is much quicker than that—but it will turn off the LCD and exposure functions. If you are spending a lot of time setting up your menus and custom features, it helps to turn this function **OFF** to prevent constantly delving back into the menu system from scratch. In normal use, however, the default setting of **1MIN** is good choice, as it conserves battery power.

OFF	1MIN	3MIN	5MIN	10MIN

🔳 USB MODE

This menu determines what the camera does when it detects a USB cord plugged into its connector panel. There is no reason to change it from the **AUTO** setting, as that ensures that the exact same screen is displayed each and every time a USB is plugged in, allowing you to choose whether you're printing or storing images at that time. Note that **MTP** is another variety of **STORAGE** designed specifically for certain Windows Vista applications.

AUTO	STORAGE	MTP	PRINT

🔳 LIVE VIEW BOOST

As described in the discussion of Live View on page 10, the LCD will, by default, accurately display any and all changes to exposure, giving you a what-you-see-is-what-you-get (WYSIWYG) preview. However, in low-light situations you may want to brighten the Live View image just to confirm composition and focus. In that case, set this function to **ON**, and the LCD will keep the Live View image as bright as possible, without regard for accurate representation of the final exposure.

OFF	ON

🔳 (Screen 2) ☻ FACE DETECT

There's no reason to bother with this setting, which activates or deactivates the Face Detection system, as it can be accessed in numerous other, more-convenient locations—namely the Live Control Menu and Super Control Panel

OFF	ON

🔳 (Screen 2) INFO SETTING

As discussed on page 41 and 73, this submenu determines which info screens appear as available shooting or playback screens. Although all the different info screens serve a pur-

pose, they do not often need to be activated all the time. Read through the chapters on these respective info screens and determine which ones you'll use the most, then deactivate the others; that way you'll be able to cycle between the valuable info screens more quickly.

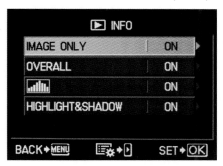

▶ INFO (Playback Info Screens)	IMAGE ONLY	OVERALL	📊 HISTOGRAM	HIGHLIGHT & SHADOW		
LV-INFO (Shooting Info Screens)	📊 HISTOGRAM	ZOOM	MULTI VIEW (Effect Preview)	IMAGE ONLY	⊞ / ⊞ / ⊞	

🎵 (Screen 2) VOLUME

A straightforward menu, this adjusts the volume of sound during playback. It is entirely unnecessary, however, because the main control dial is a dedicated volume control in all Playback screens.

0	1	2	3	4	5

🔲 (Screen 2) 🖼 SETUP

As described on page 77, this submenu determines how long each still-image slide remains on the LCD during a slideshow, and whether movie files will be played all the way through or as short snippets.

SLIDEINTERVAL	2 – 10SEC
MOVIE INTERVAL	SHORT / FULL

🔲 (Screen 2) LEVEL GAUGE

As described on page 46, this submenu activates the invaluable Level Gauge shooting info screen. I strongly recommend activating this feature, as it makes it dramatically easier to compose complicated scenes.

OFF	ON

🔲 (Screen 2) MOVIE 🎤

This submenu determines whether or not stereo sound will be recorded when shooting a movie. Since it can always be muted later, there's little reason to change this from its default ON setting.

OFF	ON

🔳 EXP/ 🔲 /ISO

This menu controls various exposure, metering, and ISO settings that have numerous effects on other features and functions. There are two screens, and the second screen has the two most important items: **ANTI-SHOCK [♦]** and **BRACK-ETING**.

The bold, saturated colors of the Vivid Picture Mode work great on high-contrast architectural shots like this. 1/640 second at f/7.1, ISO 200.

EV STEP

This determines the EV increments in which the shutter speed, aperture, and exposure compensation will increase or decrease while they are being adjusted in shooting modes. The default, 1/3EV, offers the greatest degree of fine-tuning and control, and is therefore recommended. However, if you find yourself losing shots because of the time it takes to scroll from one end of the EV spectrum to the other, increasing this setting to 1/2EV or 1EV will make that process much quicker.

1/3EV	1/2EV	1EV

▣ **METERING**

Don't waste time with this menu, as it merely controls the metering mode currently in use, which can be accessed much more quickly in the Live Control Menu and Super Control Panel

▣	◉	●	●SH	●HI

▣ **AEL METERING**

This setting determines which metering mode is used to make an autoexposure lock. By default (AUTO), the camera will use the same metering mode that is currently used in the shooting mode, which makes good sense. However, setting this to ● Spot metering can make AEL a specialized tool, capable of locking exposures on a very specific and small area of the frame—useful for difficult, contrasty, or backlit conditions.

AUTO	◉	●	●SH	●HI

▣ **ISO STEP**

Same as **EV STEP** described above, this determines the EV increments in which ISO will increase or decrease when it is adjusted in a shooting mode. And again, the **1/3EV** default is generally recommended for precision's sake; but if you want to make it easier to quickly move from lower to higher ISOs or vice versa, increase this setting to **1/2EV** or **1EV**.

1/3EV	1/2EV	1EV

▣ **ISO-AUTO SET**

As described on page 48, here you can specify the range of ISO values from which the camera will automatically choose when ISO is set to **AUTO**.

HIGH LIMIT	200-6400
DEFAULT	(in 1/3EV increments)

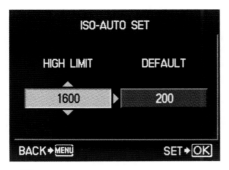

■ (Screen 2) ISO-AUTO

Don't be fooled by the name, this does not simply set the ISO to **AUTO**. Rather, it determines whether **AUTO** ISO can be used in **M** mode (which it cannot by default). I recommend setting this to **ALL**, which enables **AUTO** ISO in M mode; this way you can specify exactly the shutter speed and aperture you require, and let the camera determine a corresponding ISO for optimal exposure.

P / A / S	ALL

■ (Screen 2) BULB TIMER

This determines the maximum amount of time available in **BULB** shooting—page 34.

1MIN – 30MIN

■ (Screen 2) ANTI-SHOCK [♦]

This feature is designed to eliminate even the slightest vibration of the camera by waiting for a defined interval between cocking the shutter and firing it. In SLR photography, this is called Mirror Lock-Up, but of course the E-P1 does not have a mirror. Instead, it has a shutter that remains open before a shot is taken in order to facilitate live view; when you normally press the shutter button, the shutter rapidly cocks itself (to a closed position) and then fires. By eliminating this first step, and giving the camera an interval in which to rest, you

133

can minimize camera shake to ensure sharp photos in macro- or astrophotography. Once activated, there will be an Anti-Shock ♦ version of the existing Drive Modes available in the Live Control Menu and Super Control Panel—or via the dedicated ⟠ button.

OFF	1/8SEC – 30SEC

▣ (Screen 2) BRACKETING

Here you activate and set the EV steps of the different types of bracketing explained in detail on pages 67-68.

AE BKT	OFF	3F 0.3EV	3F 0.7EV	3F 1.0EV	
FL BKT					
ISO BKT					
WB BKT	A - B	OFF	3F 2STEP	3F 4STEP	3F 6STEP
	G - M				

▣ ⚡ CUSTOM

This menu gives access to most flash features, and sets the sync speeds in which those features will operate.

▣ FLASH MODE

Don't waste you're time here; this is much more easily accessed in the Live Control Menu or the Super Control Panel.

AUTO	👁	⚡	🚫	👁SLOW	⚡SLOW	⚡SLOW2

▣ ⚡²

Again, the flash exposure compensation is accessible via the Live Control Menu and Super Control Panel, so don't waste time by going all the way here to adjust it.

+/-3EV

⚙ ⚡ X-SYNC

As discussed on page 98, this determines the fastest possible shutter speed at which the flash will fire—and the camera will always give preference to this shutter speed, unless another one is specified in S shooting mode. For most cases, this should be left at 1/180 second.

1/60	1/80	1/100	1/125	1/160	1/180

⚙ ⚡ SLOW LIMIT

This determines the slowest possible shutter speed that can be used while still allowing the flash to fire (see page 99).

1/30	1/60	1/80	1/100	1/125	1/160	1/180

⚙ 🔃+🔃

As discussed on page 103, when this is set to **ON**, the flash exposure compensation can be combined with normal exposure compensation, allowing total compensations of up to +/-6EV.

OFF	ON

⚙ ◀ / COLOR / WB

This menu gets under the hood of the imaging processor to determine how noise is dealt with, and how the sensor renders colors and records images.

⚙ NOISE REDUCT

Short for Noise Reduction, this function is designed to eliminate noise at longer shutter speeds (see page 49). When this is set to **AUTO** and an exposure is taken with a shutter speed longer than 2 seconds, a second "dark frame" will be captured just after the original photo is recorded. The second image is used to calculate any noise that resulted from the

heat of the sensor as it remained on and exposed during the shot; that calculated noise is then subtracted from the original photo. The process takes as same length of time as the original photo's shutter speed. If set to **ON**, a dark frame will be added to every shot, regardless of the shutter speed—this is not recommended. Also, Noise Reduction is automatically deactivated in ⬚ Continuous Drive mode.

ON	OFF	AUTO

NOISE FILTER
Whereas Noise Reduction is used for longer shutter speeds, Noise Filter is used for higher ISO values—which, as discussed on page 49, can create unpleasant digital noise. If you are shooting JPEG-only, it is worth keeping an eye on this setting. For most shots, **STANDARD** is perfectly acceptable. However, if you are shooting in very dim light at the upper range of ISOs, by all means use the HIGH setting. This will lose some detail, but result in a much cleaner image.

OFF	LOW	STANDARD	HIGH

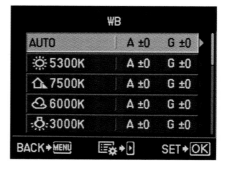

WB
This submenu allows you to make individual adjustments to all ten WB presets—including 🖵 One-Touch WB (CWB is unaffected). The amber channel can be increased in 7 increments or decreased in 7 increments toward blue; and

the green channel can likewise be increased in 7 increments or decreased in 7 increments toward magenta. As with the WB Bracketing option discussed earlier, this is an exceedingly elaborate degree of customization, and much more trouble than it's worth. If you have this much of a vested interest in perfecting the white balance, just shoot RAW and adjust it in post processing.

AUTO		**+/-7 Amber – Blue**
☼	**5300K**	
⌂	**7500K**	**+/-7 Green – Magenta**
☁	**6000K**	
☀	**3000K**	
▦1	**4000K**	
▦2	**4500K**	
▦3	**6600K**	
WB⚡	**5500K**	
▱		
CWB		**2000K – 14000K**

⊞ ALL WB±

Here you can apply a global change to all the different WB presets listed above. You can also reset any and all WB fine-tuning adjustments in the ALL RESET option.

ALL SET	+/-7 Amber – Blue
	+/-7 Green – Magenta
ALL RESET	YES
	NO

⊞ COLOR SPACE

Another frivolous menu item that is redundant with the Super Control Panel (see page 64).

sRGB	**Adobe RGB**

🔲 SHADING COMP.

This feature will automatically detect and compensate for vignetting that occurs along the edges and corners of the frame, brightening them to the same exposure level as the rest of the scene. This is an exceedingly useful feature when using wide-angle, wide-aperture legacy lenses that (as described on page 94) tend to heavily vignette on a digital sensor. But only activate this feature when you observe vignetting; otherwise it is likely to degrade image quality along the edges of perfectly fine exposures.

OFF	ON

🔲 (Screen 2) ◀︎⁝· SET

As discussed on page 60, this is where you determine which four resolution options appear in the Live Control Menu and Super Control Panel. Note that this is also the only way to access the SuperFine compression level.

◀︎⁝· 1	L, M, S (Image Sizes)
◀︎⁝· 2	
◀︎⁝· 3	SF, F, N, B
◀︎⁝· 4	(Compression Levels)

🔲 (Screen 2) PIXEL COUNT

As described on page 60, here you can set the specific resolutions of the Middle and Small Image Sizes.

Middle	3200x2400
	2560x1920
	1600x1200
Small	1280x960
	1024x768
	640x480

Obviously, the Shading Compensation function is deactivated for the Pin Hole Art Filter—as its heavy vignetting is an intended effect. 1/320 at f/4, ISO 200.

▦ RECORD ERASE

The features of this menu determine how the camera records its images to the memory card, and also how it removes them.

▦ QUICK ERASE

As mentioned on page 80, this feature bypasses the confirmation dialogue that usually pops up before a picture can be erased. It can be a great timesaving device if you find yourself deleting large numbers of pictures from the card, but it's just too easy to accidentally delete something with it. For a better timesaving way to erase pictures, see the **PRIORITY SET** option below.

OFF	ON

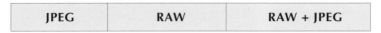 RAW+JPEG ERASE

Here you can determine which file will be erased when you click the 🗑 button while viewing an image that was saved as both a RAW and a JPEG. Whichever selection you make here will be the file type erased, and the other file format will remain on the card; and obviously, if **RAW+JPEG** is selected, both will be erased.

JPEG	RAW	RAW + JPEG

🖼 FILE NAME

This menu option allows you to decide how the camera will name the files it records each time a memory card is inserted (be it a new card or a formatted one). The **AUTO** setting will continue to increase the naming sequence based off the last shot recorded to the previous card; the **RESET** setting will begin each card from scratch, with a folder at 100 and the file name at 0001. I recommend **AUTO** here, because **RESET** will mean you end up having a lot of identically named files floating around your computer, just begging to cause confusion and disorganization.

AUTO	RESET

▓ EDIT FILENAME

Here you can customize how the camera names the files it records. In **sRGB** color space you can set the first two digits to any number or letter of your choosing, and in **AdobeRGB** you can set just the first digit.

sRGB	2 digits: A – Z or 0 – 9
AdobeRGB	1 digit: A – Z or 0 – 9

▓ PRIORITY SET

This obscurely named menu determines which option—**YES** or **NO**—appears as the default in the confirmation dialogue that appears after pressing the ▓ button (provided the **QUICK ERASE** option is disabled). By switching this option to **YES**, you can save a couple keystrokes and a lot of time when deleting large numbers of images.

YES	NO

▓ dpi SETTING

Here you can set the dpi at which the camera will record its images. This is useful if you know the specific dpi of your printer and want to format your files for easy direct printing. If you are not certain of the dpi at which you'll be printing the images, however, just leave it at AUTO, which will set the dpi according to the image size.

0001dpi – 9999dpi	AUTO

▓ UTILITY

This menu gets under the hood of a couple of different shooting features, and also offers the important PIXEL MAP-PING function.

▣ PIXEL MAPPING

Pixels die. It's a fact of life. And as they die, they can appear as black dots on an image, which will degrade the overall image quality. If you find your images to be suffering from effects of dead or "hot" pixels, run this **PIXEL MAPPING** feature, which will scan the imaging sensor for damaged pixels and isolate them, preventing them from contributing to further shots. (Don't worry, the sensor has over 12 million pixels; you can afford to lose quite a few.) Allow the camera to rest for a few minutes before starting the **PIXEL MAPPING** function, as recent use of the LCD or sensor can decrease its effectiveness.

▣ EXPOSURE SHIFT

The default exposure value of each Metering Mode is 0.0EV. If you find that—say, with an older rangefinder lens—the metering system is consistently over- or underexposing the image, you can reset the default EV of metering mode to a new value of +/-1EV in 1/6EV increments.

▣ ▭ WARNING LEVEL

This frivolous feature lets you customize at what level of charge the battery indicator will turn red to warn you that it is low. Don't bother adjusting this; even Olympus says there's no need to change it.

▣	+/-1EV
◉	+/-1EV
▣	+/-1EV

▣ LEVEL ADJUST

As mentioned on page 47, this function allows you adjust the default of the **LEVEL GAUGE** feature—useful if you find that it has become inaccurate. You can also reset it back to its factory default value.

RESET	ADJUST

142

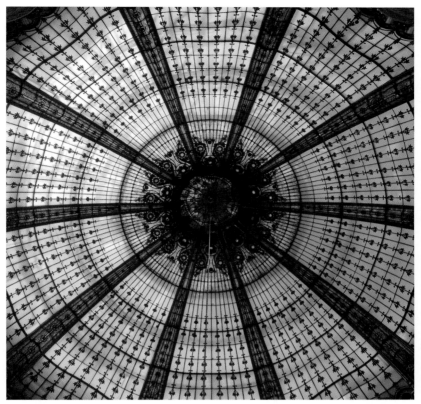

When pointed directly up, the Level Gauge's vertical bar (representing pitch) is useless, but the horizontal bar (representing roll) still works fine and can be a big help. 1/800 second at f/5.6, ISO 800.

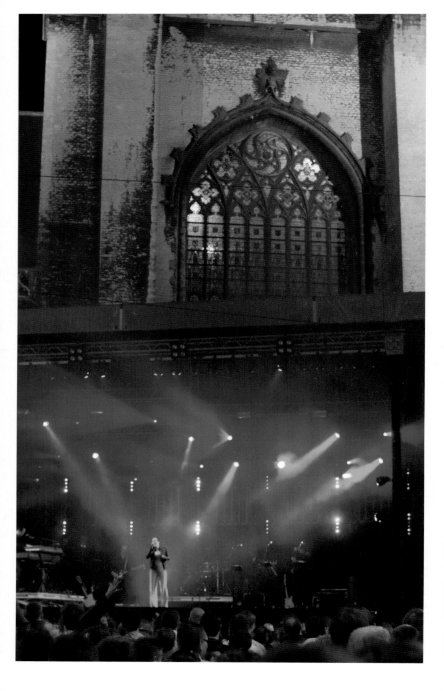

Working Digitally

Establishing a Workflow

In digital photography, capturing an image with the camera is just the beginning. After the file is written to the card, it can be processed in countless ways, printed in a variety of formats, uploaded to the web, included a multimedia presentation—the list goes on and on.

Whatever your intention is with your photography, it's important to develop an efficient workflow, customized to your own preferences, so that you can keep your files organized and your output up to a standard quality. This begins with moving the photos from the camera to your computer.

Transferring Images to a Computer

Open the connector cover on the side of the camera and plug in the small side of the USB cord into the upper USB/AV OUT socket. Then plug the large side of the USB cord into the USB socket of your computer. Turn the camera on, and the following screen will be displayed on the LCD.

A trial version of Olympus Studio is also supplied with the camera, which has a better user interface, more editing options, and the ability to control the camera from a computer using a tethered connection. Whether this is worth the additional investment is up to you, but you have 30 days to try it out and see for yourself. 1/50 second at f/2.2, ISO 1250.

Select **STORAGE**, and the computer will begin reading the memory card in the camera. The memory card will appear as a removable disk, from which the files can be copied onto your hard disk by dragging them to a specific folder. Depending on your operating system, certain default photo management programs may automatically appear and offer to do this for you.

Olympus Master 2
Supplied free with the camera, the Olympus Master 2 software offers the basics of both photo management and post processing:

○ Automatic image transfer, and organization by albums, which can be further sorted into groups
○ RAW development, in which you can process .ORF files into JPEGs according to any of the available in-camera settings—including the six Art Filters. (Note that other manufacturers' RAW formats are not supported.)
○ Basic JPEG editing, including the following functions: Resize, Crop, Insert Text, Brightness & Contrast, Color Balance, Tone Curve, Gamma, Auto Tone, Correction, Hue & Saturation, Monochrome & Sepia, Sharpness & Blur, Distortion Correction, Red-Eye Reduction, and the e-Portrait filter
○ Panoramic stitching of images shot in the ⊞ Panorama SCN mode.
○ Slideshows with music and movie playback

Firmware upgrades can serve a variety of purposes; sometimes they improve existing systems (as v1.1 is meant to improve C-AF responsiveness), and sometimes they install completely new features. 1/25 second at f/6.3, ISO 500.

o Basic movie editing with options to extract single frames as JPEGs, splice different movie files together, and upload directly to YouTube

o Batch printing options including index prints

Updating the Firmware: One critical function that can only be carried out in Olympus Master 2 is the installation of updated firmware. This function alone is worth installing the software, or at least keeping the CDs in a safe place. At time of writing, there is already one firmware upgrade available (v1.1) for both kit lenses and the E-P1 body.

To update the firmware, first make sure you have a good Internet connection and a fully charged battery in the camera. Connect the camera to the computer in **STORAGE** mode as described above, and launch the Olympus Master 2 program. Click on the Update/Language tab at the top of the program's

screen, click OK in the confirmation dialogue, and program will connect to an Olympus server to scan for any firmware updates. If updates are available, they will be listed in a new window. Highlight one of the updates, and click on the Update tab to begin the firmware upgrade.

Note: Lens and camera body firmware upgrades must be installed separately, so if you're updating both, finish one update completely, power off the camera, then repeat the steps described above for the next update.

Caution: Under no circumstances should you disconnect the camera or power down the computer until the firmware is finished installing—which will be indicated by a large OK displayed on the LCD. Interrupting the installation can seriously damage the camera.

Direct Printing

If you have a PictBridge-compatible printer (which most modern printers are), you can print photos directly from the E-P1.

Creating a DPOF (Digital Print Order Form)

A DPOF tells the printer or photo lab which pictures you want to print, and how many of each. Select the 凸 option in the ▶ menu, and you'll be prompted with two options. Selecting 凸 allows you to cycle through each individual picture on the card, designating the number of prints for each image as it is displayed on the screen. When you're done making your selections, click the ⊛ button, and you'll be given the option to have either the Date or the Time printed on each picture; selecting **NO** will print the images without any additional information. If you want to print one copy of every image on the card, select the 凸ᴬᴸᴸ option. When you're done creating your DPOF, select **SET** to save all your settings.

While online galleries and slideshows are a convenient way to share your photography, nothing compares with the satisfaction of a quality print. 1/4000 second at f/6.3, ISO 200.

Connecting the Camera to a Printer

Use the USB cord to connect the camera and printer, just as described above for connecting the camera to a computer. Turn the camera on, select **PRINT** from the menu that appears, and press ⊛ . Scroll down to **PRINT ORDER** to print according to a prepared DPOF. Additionally, you can select **ALL INDEX** to print a contact sheet composed of small thumbnails of all the images on the card. Depending on the printer in use, you may also be prompted to specify the size of the paper and the type of border used.

Glossary

angle of view
The area that can be recorded by a lens, usually measured in degrees across the diagonal of the film frame. Angle of view depends on both the focal length of the lens and the size of its image area.

aperture
The opening in the lens that allows light to enter the camera. Aperture is usually described as an f/number. The higher the f/number, the smaller the aperture; and the lower the f/number, the larger the aperture.

artificial light
Usually refers to any light source that doesn't exist in nature, such as incandescent, fluorescent, and other manufactured lighting.

automatic exposure
An option in which the camera computer system measures light and adjusts shutter speed and lens aperture to create proper image density on sensitized media.

automatic focus
When the camera automatically adjusts the lens elements to sharply render the subject.

available light
The amount of illumination at a given location that applies to natural and artificial light sources but not those supplied specifically for photography. It is also called existing light or ambient light.

backlight
Light that projects toward the camera from behind the subject.

barrel distortion
A defect in the lens that makes straight lines curve outward away from the middle of the image, like the shape of a traditional wooden barrel. Also known as negative distortion.

bracketing
A sequence of pictures taken of the same subject but varying one or more exposure settings, manually or automatically, between each exposure.

brightness

Intensity of light energy, measured by the amplitude of the light vibrations. See also, luminance.

bulb

A camera setting that allows the shutter to stay open as long as the shutter release is depressed.

chrominance noise

A form of artifact that appears as a random scattering of densely-packed colored "grain."

color space

A mapped relationship between colors and computer data about the colors.

compression

A method of reducing file size through removal of redundant data. Comes in two forms: lossy (i.e. JPEG) and lossless (i.e. TIFF).

contrast

The difference between two or more tones in terms of luminance, density, or darkness.

critical focus

The most sharply focused plane within an image.

cropping

The process of extracting a portion of the image area. If this portion of the image is enlarged, resolution is subsequently lowered.

dedicated flash

An electronic flash unit that talks with the camera, communicating things such as flash illumination, lens focal length, subject distance, and sometimes flash status.

default

Refers to various factory-set attributes or features, in this case of a camera, that can be changed by the user but can, as desired, be reset to the original factory settings.

depth of field (DOF)

The image space in front of and behind the plane of focus that appears acceptably sharp in the photograph.
Determined by aperture, focal length, and subject distance.

dpi

Dots per inch. A linear measurement of pixel density, referring to the number of dots or pixels in a linear inch. Used to define the resolution of a printer or a computer monitor.

DPOF

Digital Print Order Format. A feature that enables the camera to supply data about the printing of image files and supplementary information contained within them. The printer must be DPOF compatible for the system to operate.

EV

Exposure value. A number that quantifies the amount of light within an scene, allowing you to determine the relative combinations of aperture and shutter speed to accurately reproduce the light levels of that exposure.

exposure

When light enters the camera and reacts with the sensitized medium. The term can also refer to the amount of light that strikes the light sensitive medium.

file format

The form in which digital images are stored and recorded, e.g., JPEG, RAW, TIFF, etc.

firmware

Software that is permanently incorporated into a hardware chip. All computer-based equipment, including digital cameras, uses firmware of some kind.

flare

Unwanted light streaks or rings that appear in the viewfinder, on the recorded image, or both. It is caused by extraneous light entering the camera during shooting. Diffuse flare is uniformly reflected light that can lower the contrast of the image. Zoom lenses are susceptible to flare because they are comprised of many elements. Filters can also increase flare. Use of a lens hood, lens coating, or flare-cutting diaphragms can often reduce this undesirable effect.

focal length

When the lens is focused on infinity, it is the distance from the optical center of the lens to the focal plane.

focal plane

The plane perpendicular to the axis of the lens that is the sharpest point of focus. Also, it may be the film plane or sensor plane.

focus

An optimum sharpness or image clarity that occurs when a lens creates a sharp image by converging light rays to specific points at the focal plane. The word also refers to the act of adjusting the lens to achieve optimal image sharpness.

FP high-speed sync

Focal Plane high-speed sync. An FP mode in which the output of an electronic flash unit is pulsed to match the small opening of the shutter as it moves across the sensor, so that the flash unit can be used with higher shutter speeds than the normal flash sync limit of the camera. In this flash mode, the level of flash output is reduced and, consequently, the shooting range is reduced.

f/stop

The size of the aperture or diaphragm opening of a lens, also referred to as f/number or stop. The term stands for the ratio of the focal length (f) of the lens to the width of its aperture opening. (f/1.4 = wide opening and f/22 = narrow opening.) Each stop up (lower f/number) doubles the amount of light reaching the sensitized medium. Each stop down (higher f/number) halves the amount of light reaching the sensitized medium.

guide number (GN)

A number used to quantify the output of a flash unit. It is derived by using this formula: GN = aperture x distance. Guide numbers are expressed for a given ISO film speed in either feet or meters.

histogram

A two-dimensional graphic representation of image tones. Histograms plot brightness along the horizontal axis and number of pixels along the vertical axis, and are useful for determining if an image will be under or overexposed.

hot shoe

An electronically connected flash mount on the camera body. It enables direct connection between the camera and an external flash, and synchronizes the shutter release with the firing of the flash.

infinity

In photographic terms, the theoretical most-distant point of focus.

IS

Image Stabilization. This is a technology that reduces camera shake and vibration. It is used in lenses, binoculars, camcorders, etc.

ISO

From ISOS (Greek for equal), a term for industry standards from the International Organization for Standardization. When an ISO number is applied to film, it indicates the relative light sensitivity of the recording medi-

um. Digital sensors use film ISO equivalents, which are based on enhancing the data stream or boosting the signal.

JPEG
Joint Photographic Experts Group. This is a lossy compression file format that works with any computer and photo software. JPEG examines an image for redundant information and then removes it. It is a variable compression format because the amount of leftover data depends on the detail in the photo and the amount of compression. At low compression/high quality, the loss of data has a negligible effect on the photo. However, JPEG should not be used as a working format—the file should be reopened and saved in a format such as TIFF, which does not compress the image.

LCD
Liquid Crystal Display, which is a flat screen with two clear polarizing sheets on either side of a liquid crystal solution. When activated by an electric current, the LCD causes the crystals to either pass through or block light in order to create a colored image display.

lens
A piece of optical glass on the front of a camera that has been precisely calibrated to allow focus.

lossless
Image compression in which no data is lost.

lossy
Image compression in which data is lost and, thereby, image quality is lessened. This means that the greater the compression, the lesser the image quality.

luminance
The amount of light emitted in one direction from a surface. It can also be used as luminance noise, which is a form of noise that appears as a sprinkling of black "grain." See also, brightness, chrominance, and noise.

Manual exposure mode
A camera operating mode that requires the user to determine and set both the aperture and shutter speed. This is the opposite of automatic exposure.

memory card
A solid state removable storage medium used in digital devices. They can store still images, moving images, or sound, as well as related file

data. There are several different types, including CompactFlash, SmartMedia, and xD, or Sony's proprietary Memory Stick, to name a few. Individual card capacity is limited by available storage as well as by the size of the recorded data (determined by factors such as image resolution and file format). See also, CompactFlash (CF) card, file format.

middle gray
Halfway between black and white, it is an average gray tone with 18% reflectance. See also, gray card.

noise
The digital equivalent of grain, appearing as random dots or changes in color value in an image. It is often caused by a number of different factors, such as a high ISO setting, heat, sensor design, etc. Though usually undesirable, it may be added for creative effect using an image-processing program. See also, chrominance noise and luminance.

overexposed
When too much light is recorded with the image, causing the photo to be too light in tone.

pan
Moving the camera to follow a moving subject. When a slow shutter speed is used, this creates an image in which the subject appears sharp and the background is blurred.

pincushion distortion
A flaw in a lens that causes straight lines to bend inward toward the middle of an image. Also called positive distortion.

pixel
Derived from picture element. A pixel is the base component of a digital image. Every individual pixel can have a distinct color and tone. All other things being equal, more pixels in a digital image results in higher quality, though this is affected as well by bit depth and pixel density.

RAW
An image file format that has little internal processing applied by the camera. It contains 12-bit color information, a wider range of data than 8-bit formats such as JPEG.

RAW+JPEG
An image file format that records two files per capture; one RAW file and one JPEG file.

red-eye reduction
A feature that causes the flash to emit a brief pulse of light just before the main flash fires. This helps to reduce the effect of retinal reflection by causing the subject's pupils to contract.

resolution
The amount of data available for an image as applied to image size. It is expressed in pixels or megapixels, or sometimes as lines per inch on a monitor or dots per inch on a printed image.

saturation
The degree to which a color of fixed tone varies from the neutral, grey tone; low saturation produces pastel shades whereas high saturation gives pure color.

sharp
A term used to describe the quality of an image as clear, crisp, and perfectly focused, as opposed to fuzzy, obscure, or unfocused.

shutter
The apparatus that controls the amount of time during which light is allowed to reach the sensitized medium. That amount of time is called the shutter speed.

Shutter-priority mode
An automatic exposure mode in which you manually select the shutter speed and the camera automatically selects the aperture.

slow sync
A flash mode in which a slow shutter speed is used with the flash in order to allow low-level ambient light to be recorded by the sensitized medium.

SLR
Single-lens reflex. A camera with a mirror that reflects the image entering the lens through a pentaprism or pentamirror onto the viewfinder screen. When you take the picture, the mirror reflexes out of the way, the focal plane shutter opens, and the image is recorded.

SSWF
Super-Sonic Wave Filter. Olympus' proprietary system for preventing the accumulation of dust on the imaging sensor. Each time the camera powers on, a filter placed just in front of the sensor vibrates at a super-sonic frequency, shaking off any dust and allowing it to fall onto a small adhesive strip just below the sensor.

stop down
Reduces the size of the diaphragm opening by using a higher f/number.

stop up
Increases the size of the diaphragm opening by using a lower f/number.

thumbnail
A small representation of an image file used principally for identification purposes.

tripod
A three-legged stand that stabilizes the camera and eliminates camera shake caused by body movement or vibration. Tripods are usually adjustable for height and angle.

TTL
Through-the-Lens, i.e. TTL metering. Any metering system – ambient exposure or flash – which works through the lens. Such systems require sensors built into the camera bodies with beam splitters to transfer incoming light to the sensor systems.

USB
Universal Serial Bus. This interface standard allows outlying accessories to be plugged and unplugged from the computer while it is turned on. USB 2.0 enables high-speed data transfer.

vignetting
A reduction in light at the edge of an image due to use of a filter or an inappropriate lens hood for the particular lens.

wide-angle lens
A lens that produces a greater angle of view than you would see with your eyes, often causing the image to appear stretched.

Index